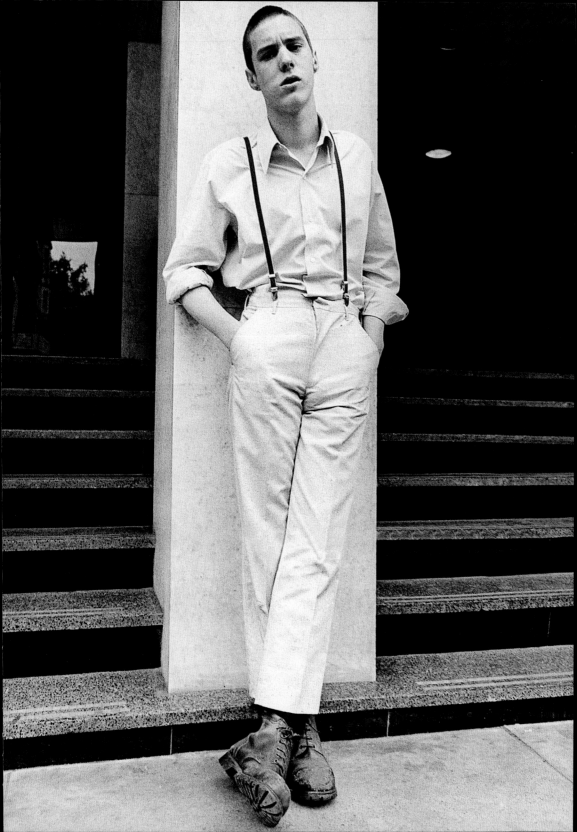

CARPET
BOMBING
CULTURE

Two Finger Salute

A catalogue record for this book is available from the British Library.

First Edition 2018
First published in Great Britain in 2018 by Carpet Bombing Culture.
An imprint of Pro-actif Communications
www.carpetbombingculture.co.uk
Email: books@carpetbombingculture.co.uk
©Carpet Bombing Culture. Pro-actif Communications

Written by: Patrick Potter

ISBN: 978-1908211-66-8

www.carpetbombingculture.co.uk

"Number two all over. Ben Sherman shirt. Braces. Doc Martens. Harrington jacket. Sheepskin. Levis. Trojan records. Ska music. Tattoos. Pints. Pubs. Football. Respect. Working class pride."

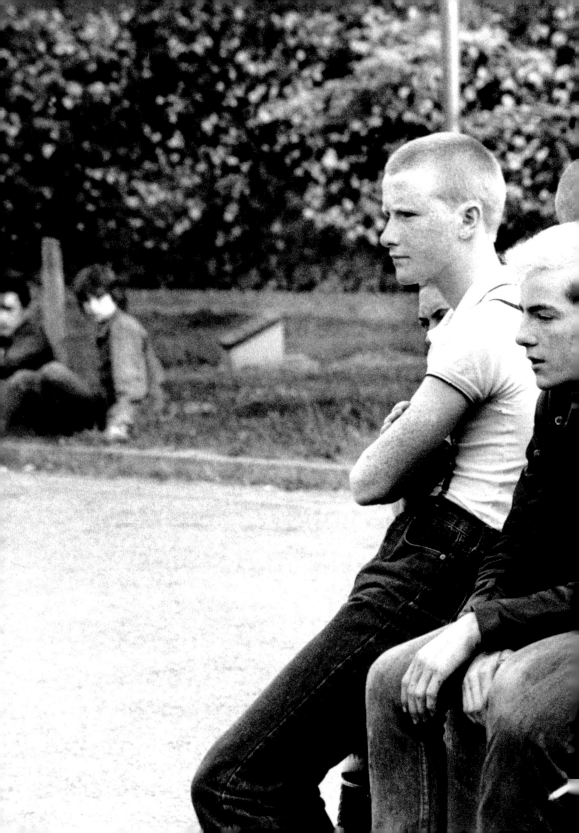

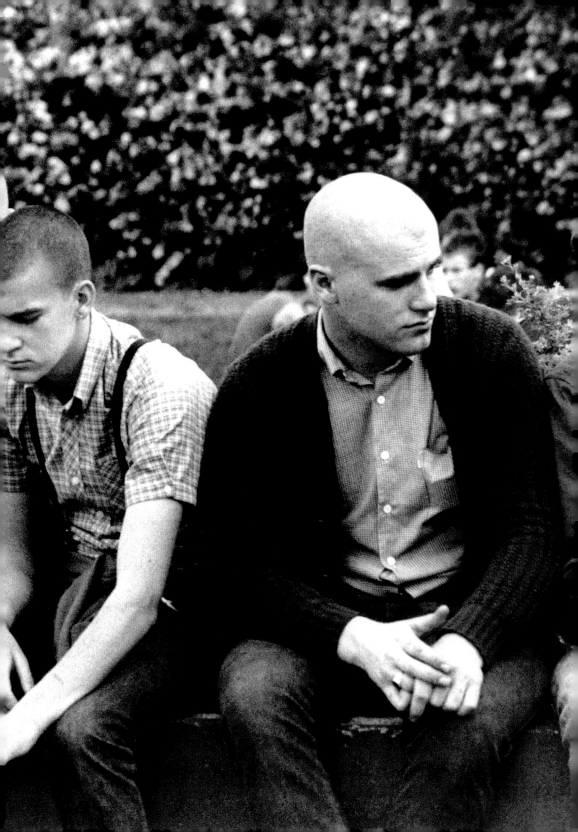

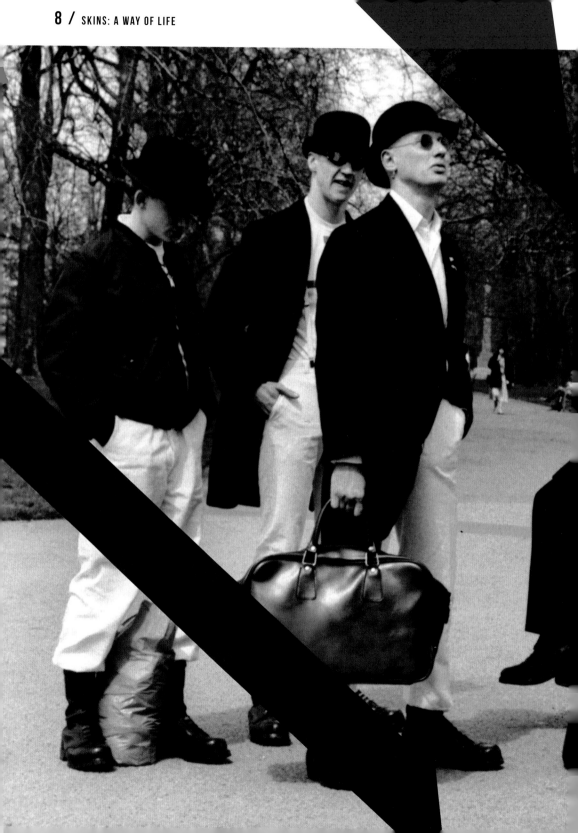

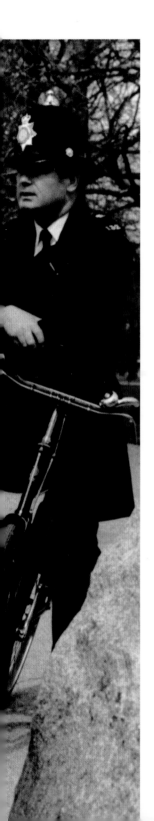

A Way of Life
IS NOT EQUAL TO
a Lifestyle

Lifestyle:

A wraparound package of mass produced products taking the worker/consumer from cradle to the grave. *The life of an object.*

Way of Life:

A life lived according to your consciously chosen values. You create your own relationships to the people, things and ideas you have available to you. *The life of a subject.*

SKINS: A WAY OF LIFE

1969 will happen again.
1969 is happening somewhere,
for someone,
right now.

The true Skins have never gone away.

Skinhead is the only British style tribe that still genuinely scares people. From the dancehalls to the football terraces, from the local pub to the tower blocks, working class teens in the late 1960's found their own form of rebellion. It didn't come from Soho.

You couldn't buy it on Carnaby Street. They looked the long-haired revolution in the eye and realised that it held nothing for them.

So they went another way...

Live the spirit of '69.

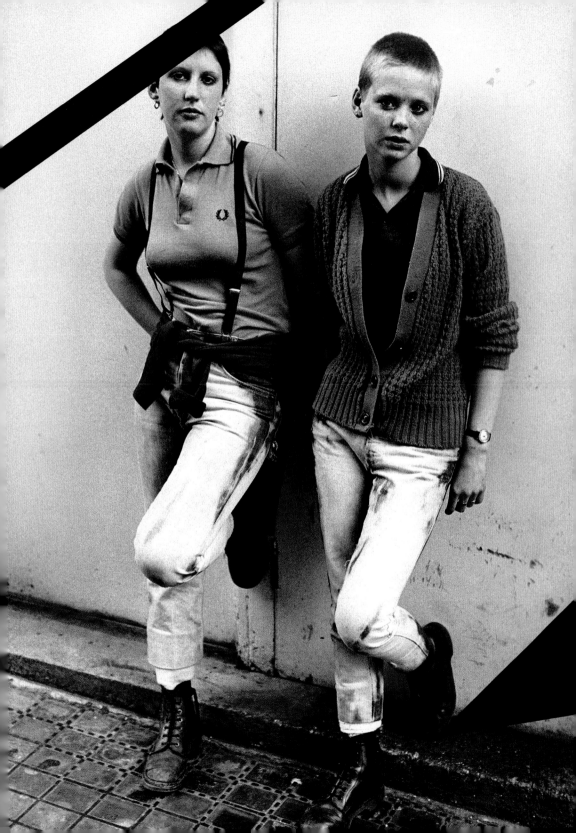

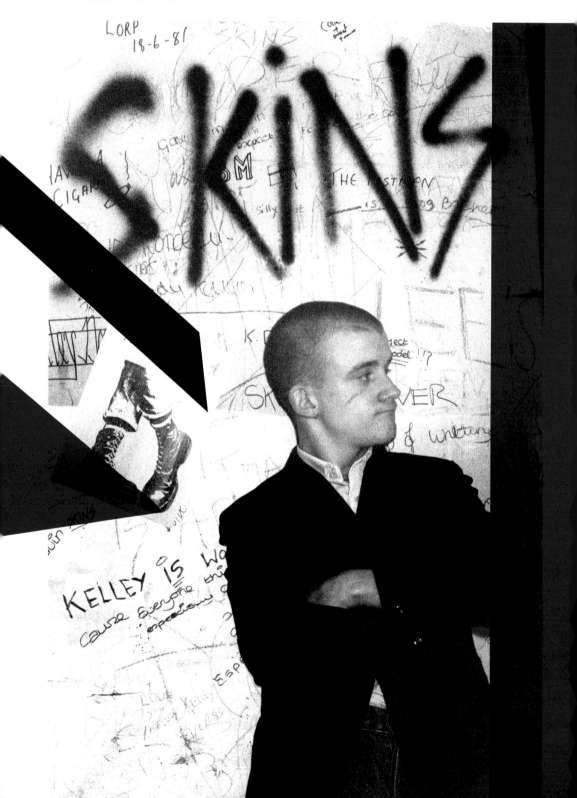

WHAT IS
A SUBCULTURE?

"There's a lot of anti-authority in those youth cults, and it's good to demonstrate to people that it was about more than just clothes, it was more of a culture."
Danny Hogan, Pulp Press

No matter how many years drift by there is a gap in the heart that is never filled. The nostalgia for paradise lost - that moment when we discovered a world that made sense, we found our tribe - our people. And then almost immediately we realised that it was a world that could not be sustained. These lifestyles were too intense. The light that burns twice as bright burns half as long.

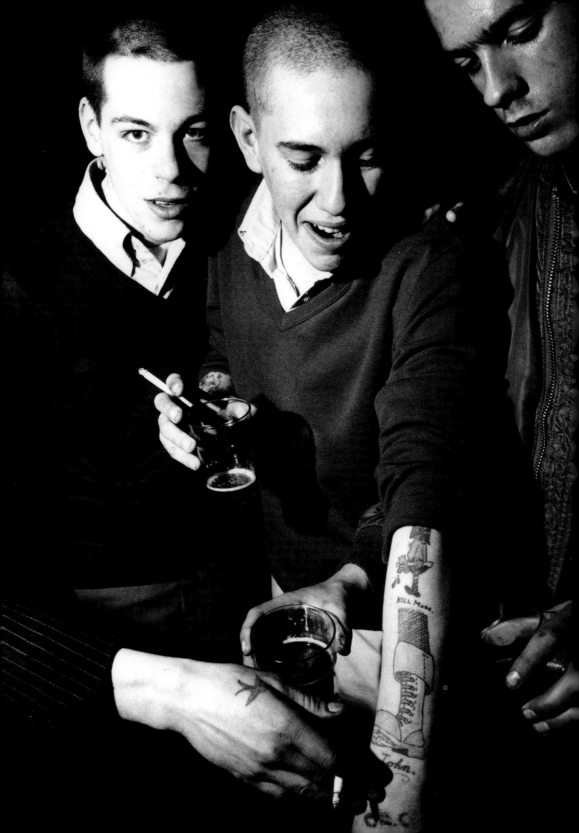

A subculture is an imagined solution to a real problem. The 20th Century brought a whole host of new problems to British society that the older generation had no way of understanding. It was left to the young to try and figure out new responses to the new world.

Youth subcultures are just one possible response - and in one sense they are a collective retreat into an imaginary world - in another sense they were a revolutionary impulse against the world which exists. Through pure, blind faith and intoxication, you could believe for a minute that your subculture might actually become a new reality. Of course it never did.

They were always doomed, precisely because they were IMAGINED solutions to REAL problems. Being a Mod, or a Skin or a Punk would never offer you a career and a pension - it couldn't solve the problem of your real life.

The Skins were thrice damned in this sense because their culture tried to break away from traditional working class submissiveness, and at the same time totally refuse the trappings of the new, trendy middle class culture. Just like many rappers today, they were caught between two forces - the want for finer things and a more exciting life, and the need to stay authentic to their roots.

To become a Skin was to aggravate and increase the problems of your real life, to welcome the discrimination and fear of other people. In a sense, they embraced their marginalisation and amplified it - making their oppression doubly visible. Hated by all factions of the middle class they were crucified by the media. In spite of their contraditions there was something there - some spark of revolutionary power that continues to haunt us. There was SOMETHING THERE.

Join us as we hunt for the truth behind the image of the most terrifying youth cult of them all - The Skinheads.

THERE AIN'T GONNA BE A REVOLUTION

1966. Mod culture was dying. England won the world cup. The psychedelic wave of hippy culture was rising. But it did not appeal to all the kids. Not the ones from the rougher new estates...

Don't give me your Hippy revolution. I don't trust it. You can tune in and drop out because you know daddy can bail you out later. I'm gonna work hard and I'm gonna play harder. You keep the LSD and I'll keep the speed. You keep Pink Floyd and I'll have Desmond Dekker. There ain't gonna be no revolution.

There ain't gonna be no classless society. But we don't care.

We've got the pub, the terrace and the Mecca dancehall on a Saturday night. We will always have our neighbourhoods, our communities - we'll always have each other.

WE HAVE OUR PRIDE. WE HAVE OUR RESPECT. WE KNOW HOW TO FIGHT.

We love Jamaican street style. We love American soul music. We wear German boots. And I'll tell you a secret...a lot of us used to be Mods.

Above all: WE LOVE THE MUSIC.

Trojan records, launched in 1968, becomes the symbol of the original Skinhead movement. Ska, Rocksteady, Reggae and Dub were outsider scenes that attracted working class outsider youth. They laid the foundations for all the British subcultures that followed.

Skins have never been more relevant. In a time when we are sold the lie that all working class people are racists, and that all cultural movements come from art school kids with professional parents - it's time for the spirit of '69 to shine again.

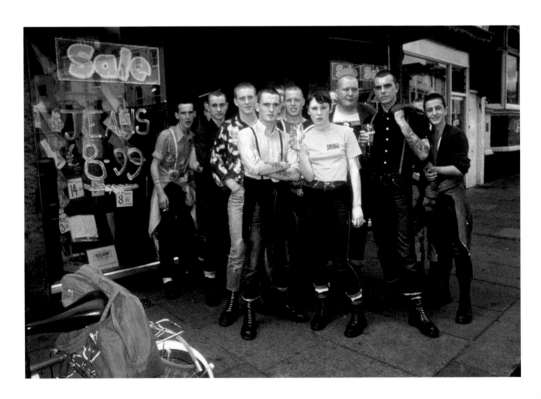

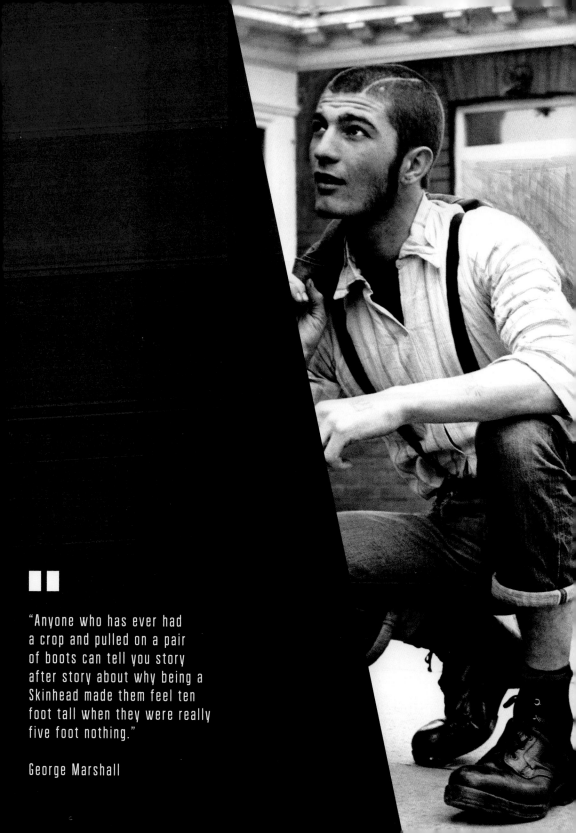

"Anyone who has ever had
a crop and pulled on a pair
of boots can tell you story
after story about why being a
Skinhead made them feel ten
foot tall when they were really
five foot nothing."

George Marshall

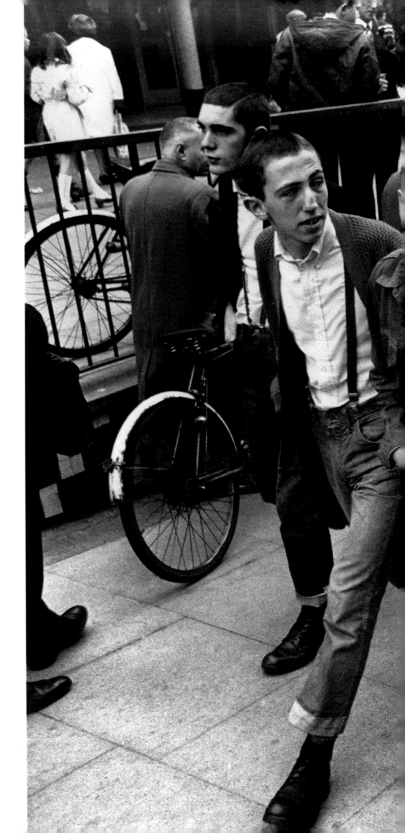

Coventry shopping
precinct, 4th October
1969.

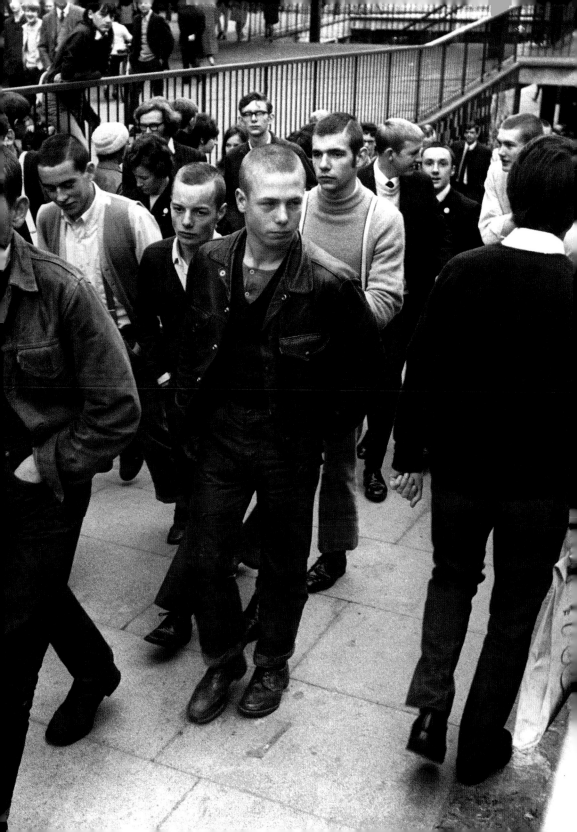

SKINHEADS

In the 1960's the Mod scene peaked around 1964. A lot of the younger, rougher, tougher Mod kids began to evolve a harder edged version of the Mod style. You can see them in photographs of the Bank Holiday 'riots' of the era. In amongst the suited Mods, proto-Skinheads swarmed the beaches 'noising up' the Greasers.

In 1966 the cool, tight Mod style was out. Hippies, Psychedelia and the Peacock Revolution were in. Hippies looked like tramps or Jethro Tull. Swinging Londoners were a wealthy elite - the clothes were foppish, extravagant and expensive. Working class kids looked on appalled - this was not a party they wanted to go to, and they weren't invited anyway. They turned away from this middle class revolution to find inspiration elsewhere.

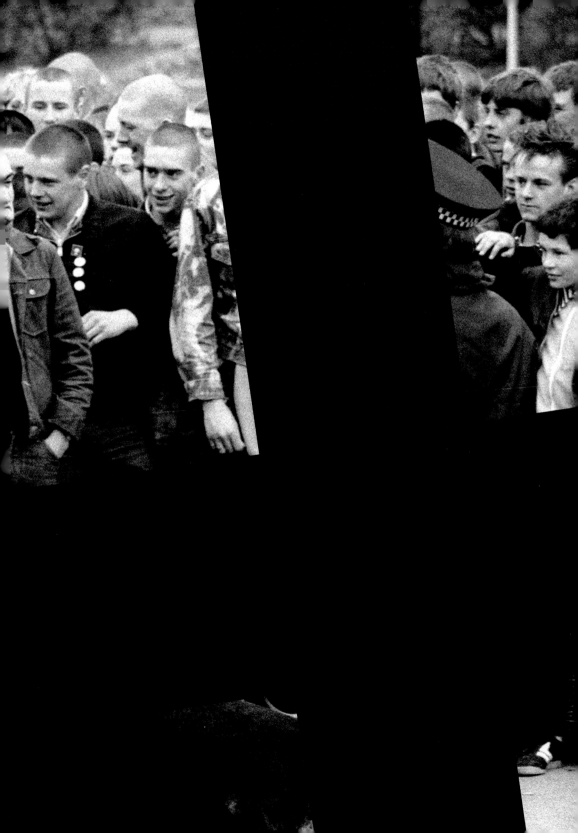

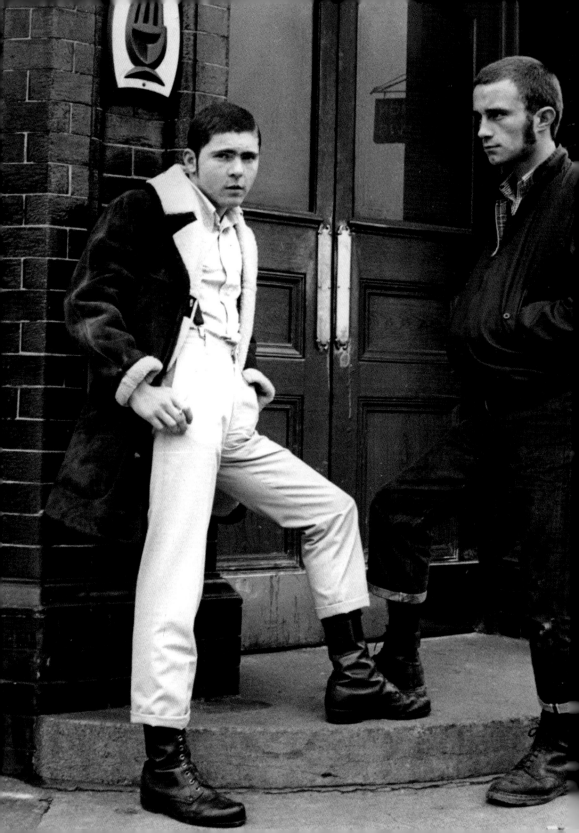

And they found it in Ska and the Rudie Street Style. This was clean, tight dance music, still underground - reviled by the mainstream. The look was streetwise and tough. It suited kids who'd grown up idolising East-End gangsters, not Alan Ginsberg or Timothy Leary.

They wore suits to go dancing and boots to go the football. If they had the money, they'd go shopping up Richmond to John Simon's Ivy shop (just ask Steve Jones from The Sex Pistols about his shopping trips there) and buy pieces like the Baracuta Harrington that their Mod big brothers would certainly have worn. They cut their hair short, but never bald. It was a few years before they were finally known as Skinheads - a term they would not have used themselves. They loved Ska, they loved it so much that Ska artists made songs dedicated to them like Symarip's 'Skinhead Moonstomp'. And they loved football.

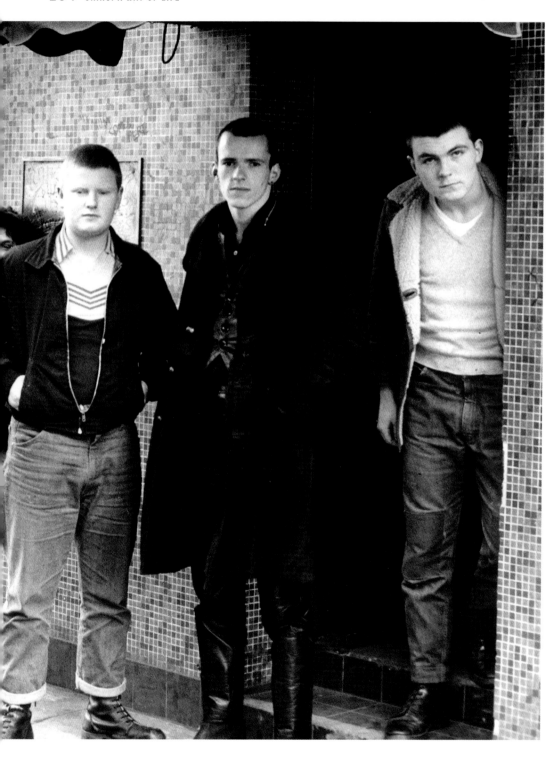

It all peaked around 1969. Then, the original Skins grew up and moved on. Some became Suedeheads or Smoothes. Some moved onto Glam rock. Some moved onto football hooliganism. The scene ebbed in London, but it grew in the regions, popularised on the terraces of the nation by London bootboys at away games.

Then Punk happened. The Punk explosion in 1977 was the catalyst that brought the Skinhead style back from the dead. A whole new generation of Skins arrived, and ex-Skins got back into the style. It was a time of tribes - there was a Mod revival and a Ska revival happening. Zines ensured that Skinhead traditions were passed on to the newcomers - but they didn't stop a schism occurring, Traditional Skins and Punk Skins diverged in style. The latter having less of a Mod influence, introducing tattoos, longer boots and military elements like the MA-1 flight jacket.

During the years 1977 to 1985 fascist groups in the UK capitalised on generalised fear of immigrants to win electoral successes. They tried to recruit teenagers by targeting Oi and 2-Tone gigs. The highly visible presence of a minority of fascists Skins at Oi! gigs was sensationalised by the media - the link between Skins and Fascism was cemented in the public eye.

As a result, Skinhead numbers dwindled by the mid to late 80's. Some moved on to Acid House and discovered ecstacy or pushed football violence to the extreme and became Casuals. By the 1990's the scene belonged to a small and dedicated group of die hards like George Marshall and the Glasgow Spy Kids, who fought to distance Skins from 'Nazi Bonehead' culture, and to rescue their Trojan legacy.

Today, Skins remain a thriving and international subculture, well aware of their roots and values, standing for working class pride and community spirit, regardless of the colour of your skin.

And that's the story in a nutshell. Well, it's the best I can do anyway.

If you don't like it - write your own.

SKINHEAD CHARACTER NOTES

Imagine you are an actor about to play the part of an original, traditional, spirit of '69, Trojan Skin. You're going to be one of the first wave of kids to coin the style and define its' roots. You were there, at the start of it all, before the term Skinhead even existed.

Who are you? Where do you come from? How did you become a member of this brand new youth cult?

These are your character notes...

It is 1966. You are fourteen-years-old. You live in East London. You can just about remember when your family moved into the new flat on the Lansbury Estate. Your mum and dad grew up in a terrace of little houses around Bethnal Green, what they called 'slum housing' before they knocked them down. Most of their friends and family moved further away, but your dad still had a steady job on the docks so the council found you a place in Poplar.

Your parents work hard. Mum has a job in one of the few remaining manufacturing industries clinging on in East London. Perhaps she treats furs to be used for fancy coats to sell up West. Your extended family, once tight knit, has been scattered. Your parents are both still working when you get home from school. You spend a lot of time roaming around with a gang of mates. There are derelict buildings and wastelands to explore.

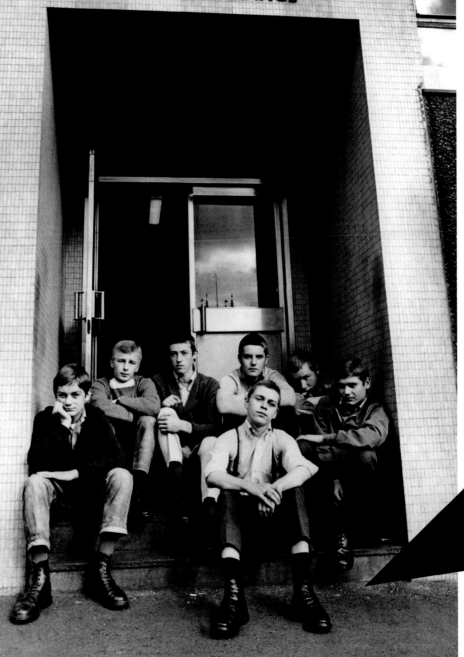

You are not doing well at school. It is already understood that you will leave at fifteen and go looking for work. Your dad, or an uncle somewhere will give you an in on something. Your dad warns you off dock work, it's got no future in it. Maybe you'll get an HGV license and drive a lorry. Maybe you'll head out to Essex and get into the car factories.

You are looking forward to having money for clothes. You've seen the Mods, your big brother looking sharp in his own version of that preppy Ivy League style. You want to look like you're going places. Like your parents, looking presentable is important to you. It's a fine line between respectable poor and filthy poverty. You cannot understand this hippy scruffiness - it's a disgusting lack of self-respect.

You live in between two worlds. The space race is on telly, and yet there are still rag and bone men working the streets. People still get coal deliveries. There's even a few working horses left in London. For some this is the Swinging Sixties, Carnaby Street is in full 'Austin Powers' mode. Miniskirts, psychedelic rock and the sexual revolution. This is not a world you have access to - but you're not immune to the drive for rebelling against your parents' spartan values.

Violence is a part of your life. The East End is routinely depicted as a criminal slum in the press and popular culture. You are aware of this. People tell stories about your area, true and otherwise. The tabloid press love an East End gangster story. You know the families to avoid on your estate. If you get in trouble with the fuzz you will get a slap at home from mum or dad. There are territorial scuffles with other gangs of local kids. It pays to look hard. You get less trouble if you don't look like a soft touch. Boots and a severe haircut can go a long way. Boots can make you feel ten feet tall.

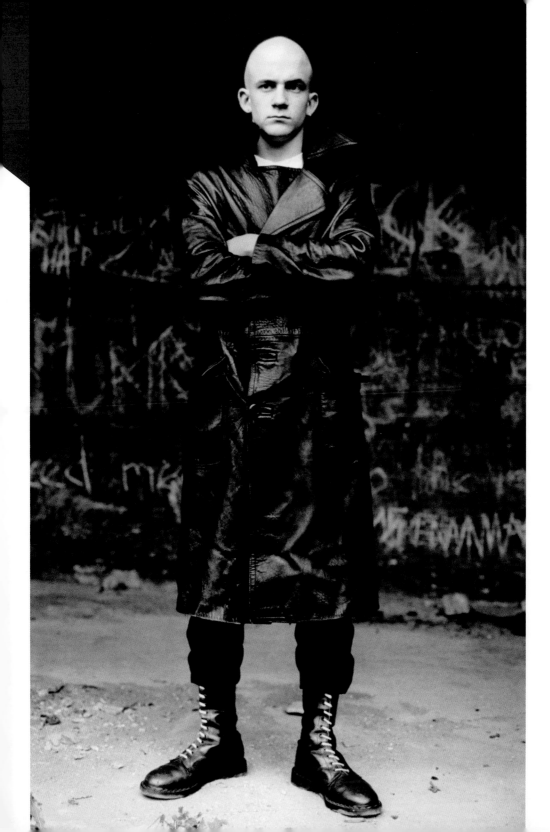

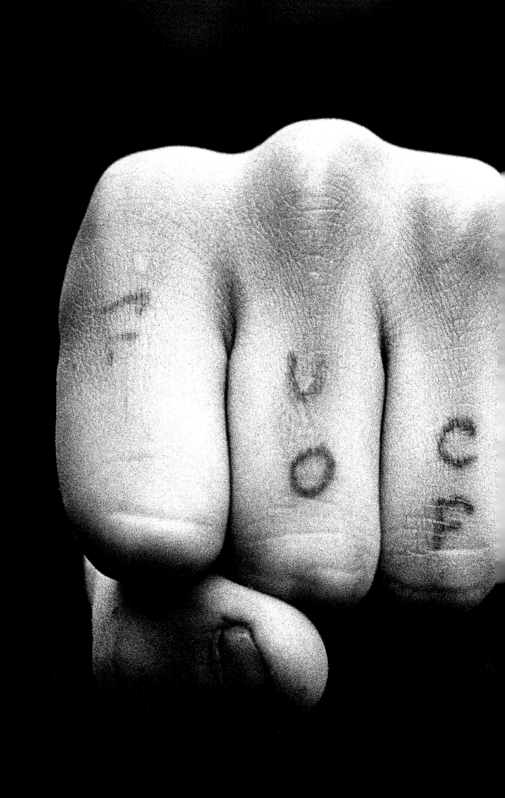

Your dad rents a TV from Radio Rentals, so you all watched the world cup final together at home with some friends and family on Saturday 30th July. It was a beautiful moment. Your dad used to take you to games occasionally when you were younger, but now you go with your mates - as often as you can afford it. You're a Millwall fan.

Fast forward two years. You're a working man now at the age of sixteen. You won't think about leaving home until you are ready to marry. So you give your mum some of your pay packet and the rest is spending money. You buy your first Baracuta Harrington jacket at the Ivy Shop. You and your mates have started going to parties out West where they play 'Blue Beat', mixing with the West Indian crowd. The Rudeboys and the Skins are all together, united in their outsider status.

For a couple of years this is paradise. You live for the weekend. You look cool, you go to the best parties. You do your Skinhead stomp. You get to the football when you can. There are a few fights, not too serious. There are a few women, not too serious. Nobody disrespects you to your face. Loved by your friends, feared by your enemies. You have made your own version of cool, built on pride and passion.

You are living the Skinhead dream. You are the spirit of '69.

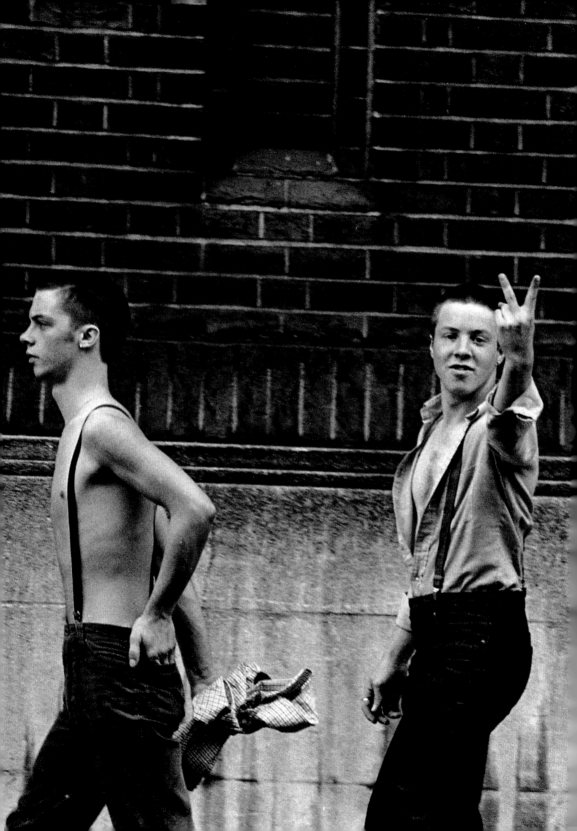

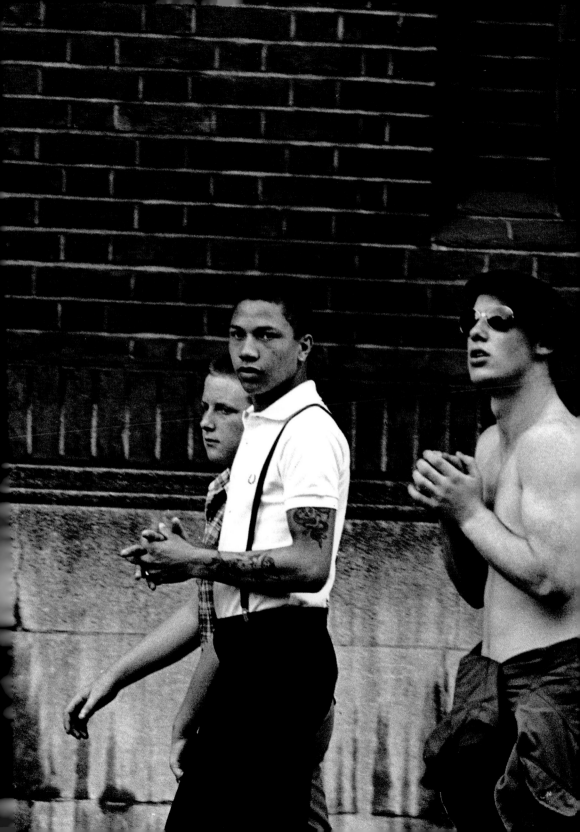

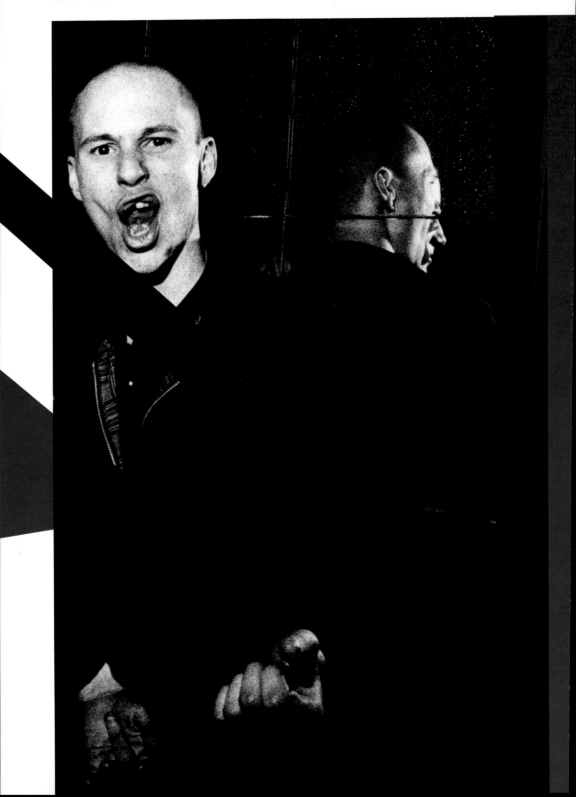

BONEHEADS

Changing the nations perceptions with the help of a number 2 grade clipper guard since 1969.

It doesn't matter really, how you behave, when you walk down the street with no hair - people respond to you differently. It is subtle, but you notice it. Even if you're skinny as a rake - people start to respond to you as if you were a threat.

They won't be rude, we're British after all, but it'll show in subtle details. People will swerve you a little wider on the pavement. Some will be excessively polite. Some will challenge you - walk directly at you or give you a shade too much eye contact.

You've bought a cheap ticket to hard man / woman status. It is crazy how literal we are. We read signs and just believe them. You see the haircut with the boots - boom. You might not look at anything else, we summarise in a second or two. You could probably get away with wearing the boots plus a Skinhead crop and even wear a flowered shirt. People would still treat you as if you were hard.

"They were like an army, they just had this impression on me you know what I mean? So that was it, I went home, got my hair cut, stole my brother's work boots, nicked my father's braces and I became a Skinhead."

Roddy Moreno,
The Oppressed

It is probably the easiest way a white man can get to experience a bit of discrimination.

There are upsides and downsides. If you pair the look with the right kind of walk and the right kind of stare - you can dodge a lot of harassment in the street. Loads of girls will want to stroke your head. You'll get served quicker at the bar.

But you probably won't ace that job interview.

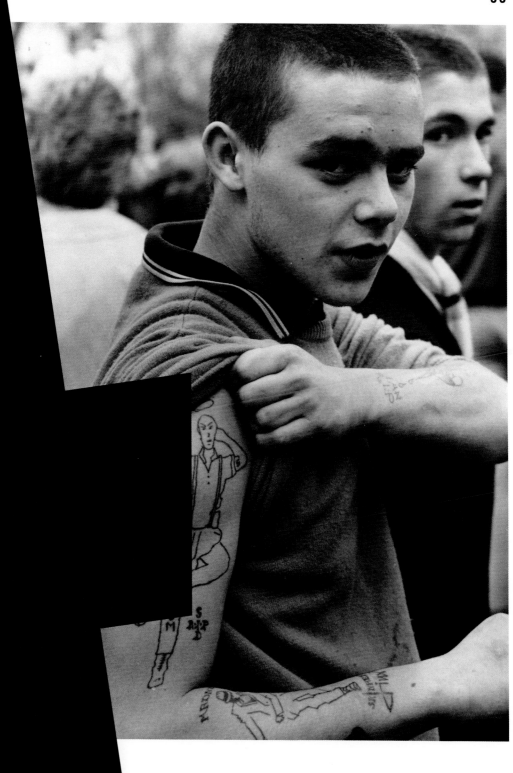

WE NEVER LOCKED OUR DOORS

If the Mods had been united by a quest for 'the modern' then Skinheads were united by a pride in their working class roots, 'the traditional'. In the late 1960's the traditional working class communities were all but gone. The grand new housing schemes of the Labour governments were meant to raise the standard of living, which in some ways they did, however something got lost along the way. The nostalgia for the old way of life cast a long shadow - and the young men and women who grew up in this shadow inherited a belief in a golden age where 'we was all together' and nobody ever had to lock their front door.

In these old communities children were raised by the whole street. They called all the women 'aunty' and there was no such thing as 'childcare' because someone was always around to watch the kids. The business of living was all done in public. The modern concept of privacy meant little. Public wash houses for the laundry, small local businesses like hairdressers, local pubs which seemed to be on every street corner - life was lived in these public spaces. People rarely hung around indoors.

Squinting back on this - it seems a utopia, if you forget the ever present threat of destitution or the mounting bills. People helped each other. They had something that most of us in modern Britain have never experienced. They had a community.

This way of life was not completely dead when the young Skinheads first appeared on the scene. Your 1969 Skinhead had a dad who had lived through World War II and a grandad who had been born in Victorian London. He was closer to Charles Dickens' East End than he was to

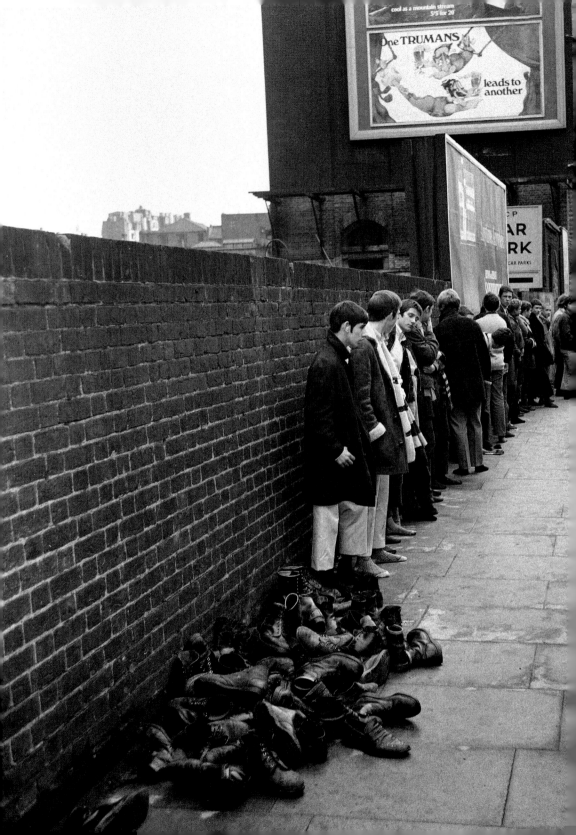

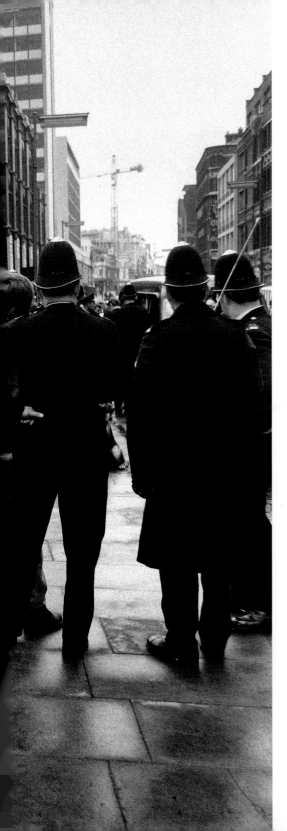

the Olympic Park, Stratford. His parents had lived through the Blitz. Of course he was 'for the flag'.

That deep human need for togetherness, community and identity is often expressed through nostalgia for a golden age. And golden ages are a funny old cocktail of reality and fantasy. Fascination with the cockney golden age has had lasting power, and it was a fundamental element of the Skinhead subculture.

Even when the Skinhead culture spread out to the rest of the UK it carried this element with it. Because in the wider nation the same pattern was playing out for working class communities from all over the British Isles from Manchester to Belfast, Glasgow to Birmingham. They were being pushed out of urban areas to new housing developments in the name of modernisation. They got their indoor toilets but they lost their extended families. The old values of mutual support were giving way to the aggressive individualism of modern life.

This history gave Skinheads their source of pride and identity - but it also gave them a sense of having been robbed of something precious. In the 1960's the effects of the post war boom insulated society against this source of working class rage - but the 1970's were a different story...

Left: Skinheads clash in Farringdon Road, London, 4th April 1970.

A MESSAGE TO YOU RUDIES

The influence of Jamaican street style on the Skins is fundamental. So who exactly were the rudies who inspired the fashion sense of those early Skinheads? To understand that, you need to go back to colonial history.

Jamaica was conquered by the English in 1655 and it remained under colonial rule until 1962. Until emancipation in 1834, the majority of the islanders were slaves working the sugar plantations. The British brought in hundreds of thousands of enslaved africans, forefathers of today's largely afro-caribbean population.

In the early 20th century, movements to improve life for ordinary Jamaicans emerged and Marcus Garvey emerged to become modern Jamaica's first national hero. Around the same time, in the 1930's Rastafarianism began - which would later have a massive impact on Jamaican youth culture. Self-rule was gradually implemented from 1944 through to 1962.

Back in London in 1948, the government was faced with a labour shortage due the losses of the war. They granted citizenship to anyone living in the colonies and invited people to

"Skinhead was always, always, a multiculturalist thing, Skinhead was born of a mix marriage between Jamaican culture and white working class London culture, cockney culture"

Don Letts, BBC The Story of Skinhead

Right: West Indian Immigrants arriving in the UK, 30th June 1962.

settle. Various recruitment drives, such as London Transport, were directly targeted at Jamaicans. There were good reasons for them to come.

Life in Jamaica was tough, there were massive infrastructural problems, unemployment and poverty. Kingston had a reputation for organised crime, street corner gangsters were known as Rude Boys or Rudies. Just like the east-end gangster in London, the Rudies were style idols for many young people in the West Indies. But unlike London, tailoring was available to the working man in Jamaica - as there was a long tradition of having a neighbourhood tailor. This meant that the young men who boarded ships to seek their fortune in London often stepped off the boat in tailor made suits.

The Windrush Generation were the first wave of West Indian migrants to the UK and stylistically they would have been influenced mainly by the sounds of American R&B or Swing Jazz and the associated 'Zoot Suit' look. However, there was always a Caribbean twist in details of the cut or the choice of fabric. These guys were cool, but they were not yet the Rudies who inspired the Mods and the Skins.

Ten years after the Windrush arrived the atmosphere for West Indian newcomers was much more toxic. The young Jamaican man in London adopted a sharper, more hard edged look, directly inspired by Kingston Gangsters, who in turn had taken US influences and given them a unique Jamaican twist. The cool, sharp style came from the Jazz Modernists of the 1950's. The Jamaicans added the two-tone fabric, the shortened trouser with white socks, the pork pie hat and a very short hair crop called the Skiffle. This style went hand in hand with the evolution of Ska, which had grown out of American R&B.

This super-cool, stoic and tough style was in stark contrast to all the psychedelic silliness of swinging London. As the harder Mods saw their culture descending into

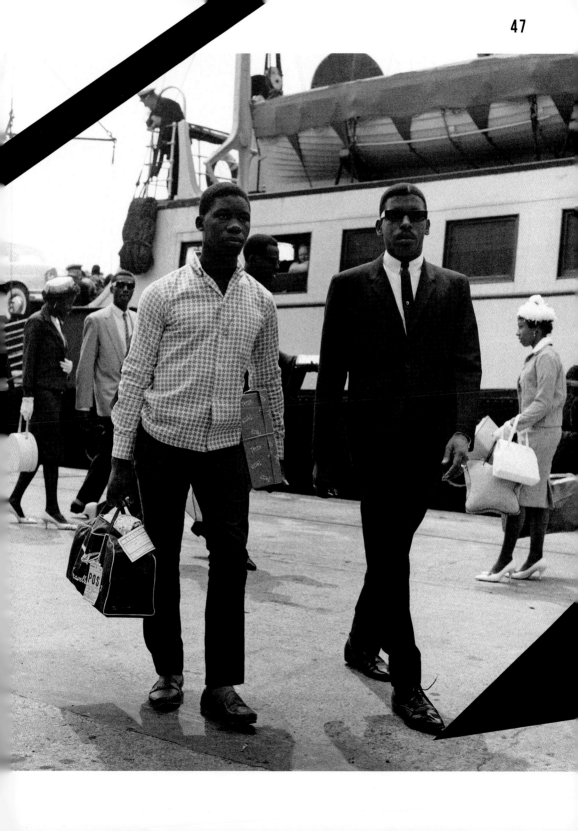

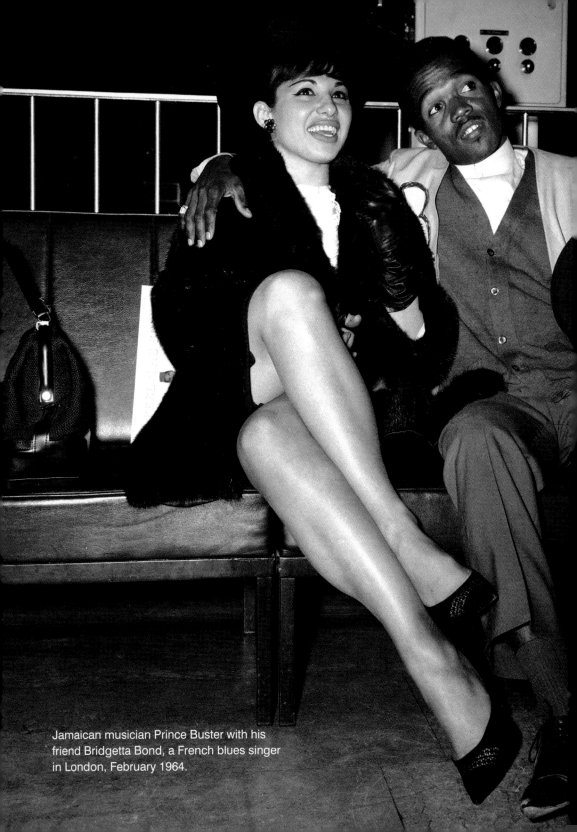

Jamaican musician Prince Buster with his
friend Bridgetta Bond, a French blues singer
in London, February 1964.

the peacock revolution, (later immortalised by Austin Powers) they choked on their collective espresso bar coffees. They suddenly realised that they had more in common with working class Jamaicans than they had with the clique of public schoolboys who had hijacked their youth rebellion. And for a time this mutual understanding flourished.

But fashion moves fast, and the Rudies were changing. As Ska gave way to Reggae and Dub the music got more political. Tracks like 'Young, Gifted and Black' covered by Prince Buster didn't make much sense to the white Skinheads at the Ska party.

Reggae artists, especially Bob Marley began to champion Rastafarianism which shifted the Jamaican street style firmly in the direction of rootsy, natural vibes, sometimes combined with a military element - far removed from Rudie sharpness. This wasn't true for all West Indians, the 1972 Jamaican gangster movie 'The Harder They Come' starring Jimmy Cliff showed that the Rudies back in Kingston were going in the direction of American Funk, again with a fabulous Carribean twist.

The Rudie style never died though and it blew up again with the 2-Tone revival in the late 1970's. It remains an essential reference point in British street style.

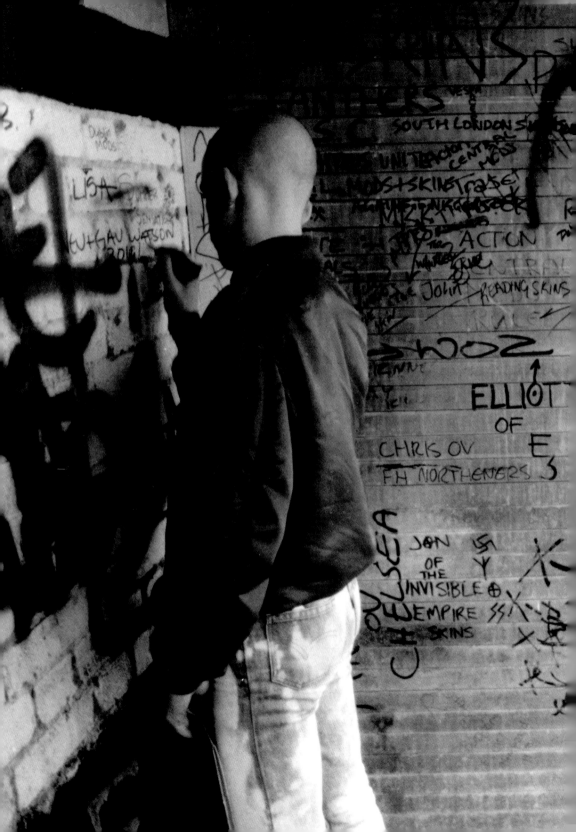

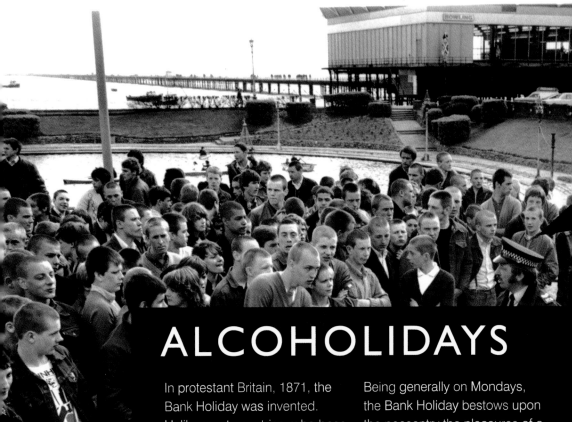

ALCOHOLIDAYS

In protestant Britain, 1871, the Bank Holiday was invented. Unlike most countries, who base their public festivals on religious calendars or historic dates - the British base them on whether or not the banks are open.

Being generally on Mondays, the Bank Holiday bestows upon the peasantry the pleasures of a three day weekend. The British worker has long since elected to spend these days drinking from lunchtime onwards.

■■

"They were down the social ladder in etiquette but in pole position as far as being sharp, sussed and street wise is concerned."

Hand in Glove, Blog

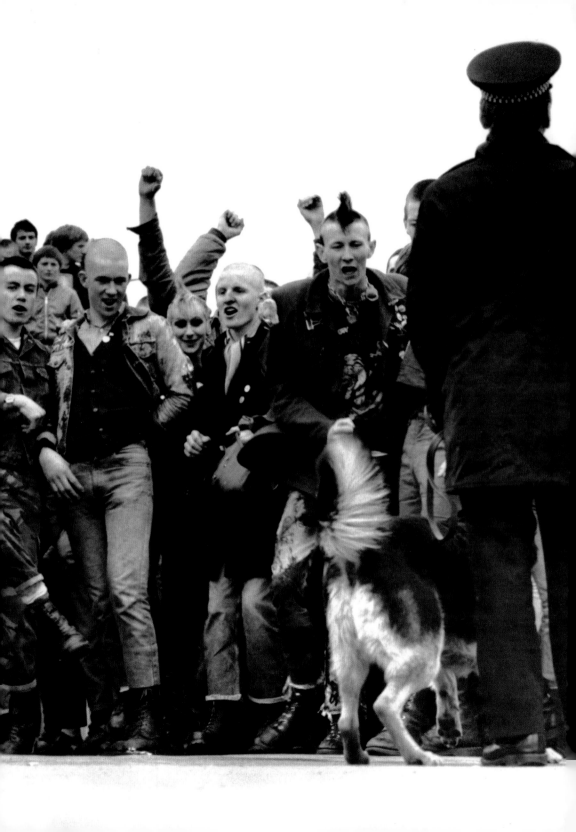

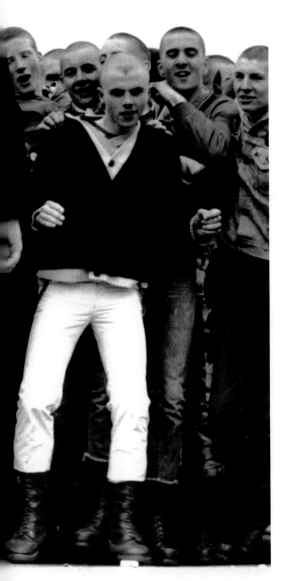

The spirit of the Bank Holiday weekend can be traced back to medieval times. In the 1600's, Shrovetide was a time of reversal, a time when people could go batshit crazy and totally get away with it. What goes on at Shrovetide, stays at Shrovetide - like a middle ages version of the purge. (The ruling classes knew the value of having a social safety valve to ward off a peasant revolt.)

Boozing, fighting, shagging and dressing up in daft costumes was also way to drive out the spirits of winter and welcome the spring - long before it became a standard Saturday night out.

Later, in the early part of the twentieth century, working life had become urban and industrialised and employers began to offer something called a 'beano'. The factory owner would organise an annual company booze up, usually at a pub in the countryside or sometimes down to the coast. He would make a great display of paying some of the costs but workers would also contribute through the year toward the beano fund.

There is a fantastically detailed description of a Beano circa 1906 in 'The Ragged Trousered Philanthropists' showing how the event starts out full of joy and song then gradually descends and gets messier, much as Bank Holiday piss-ups do today.

By the time youth style tribes like the Teds, Mods and Skins came into the public eye - there was already a long tradition of working class people from London going to seaside resorts such as Great Yarmouth, Southend, Brighton and Hastings. Mostly they went by train, even at the height of scooter culture - and most were not obviously affiliated to any particular youth cult. The type of rowdy behaviour they engaged in was never very serious - just the overexcited aggravation of frustrated teens letting loose. More than 70% of arrests at the so called Mods vs Rocker riots were for swearing and shouting. Contrast these 60's skirmishes with the 80's Skinhead invasions, from Brighton and Southend up to Scarborough and Blackpool, the traditional Bank Holiday became an orgy of violence and confrontation as opposing tribes faced off on sea fronts the length and breadth of Britain.

The Victorian licensing laws and their antiquated closing hours contributed to the violent outcome by forcing the visitors to cram as many pints as they could in before closing at 2.30 p.m. and forcing them all back out on the streets to cause mayhem.

Today, Bank Holidays are still the focal point of subcultural happenings in the UK. In many ways, they have helped to shape the history of British youth culture.

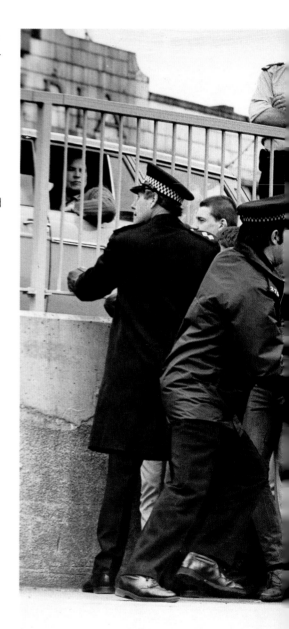

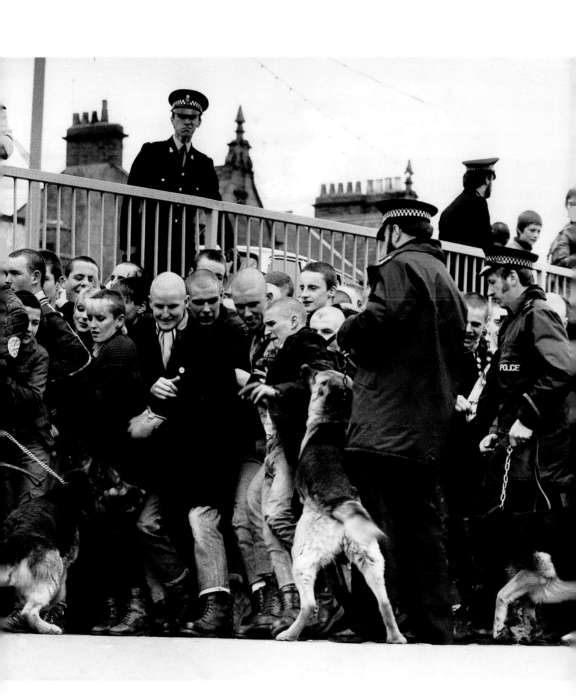

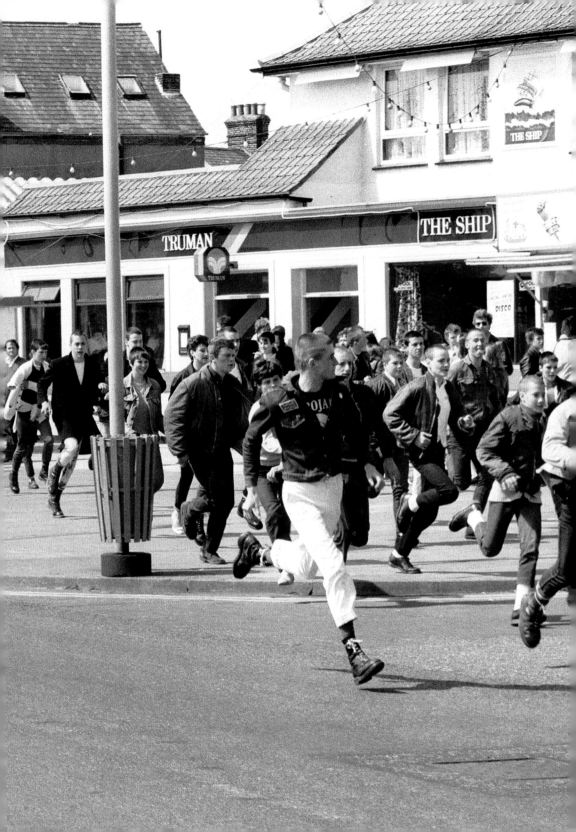

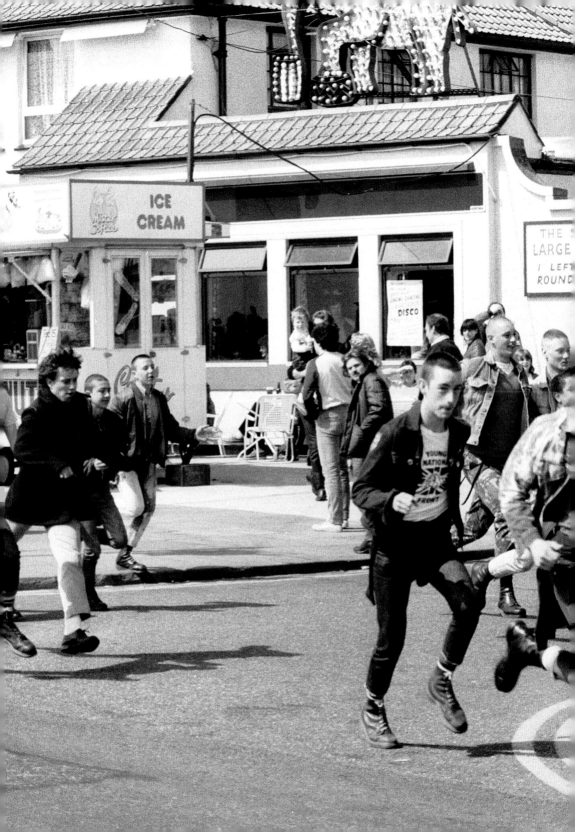

SCISSORS AND SARTORIAL DEVIATIONS

"Your attitude hasn't changed much since you were a Skinhead. Probably because your attitude never changed when you became a Skinhead. You were never going to take shit off anyone, and that will never change."

(2012, A Suedehead Manifesto, forthesuits)

The Suedeheads were not content to look exactly like every other Skin in town. They revived a Mod-like attitude to dressing sharp at all times, elevating the Skin style but maintaining the hard edge. There weren't many of them, and their heyday didn't last long but their version of Skinhead style casts a long shadow and there are small numbers of sussed Skins today who still love the look and the attitude of the Suedehead.

The Suede is essentially a Skinhead who has evolved in subtle and sartorial directions. He's more interested in women, and dressing up to impress them. He's less interested in hanging around on street corners with a dozen lairy fifteen-year-olds. He'll still have you, if you take the piss, but he'd rather have a pint and talk about rare soul, reggae and rocksteady records.

While the Skinheads dressed for manual labour the Suede's aesthetic was firmly routed in refinement and detail. Where Skinheads were confined to the typical British boozer due to their abrasive appearance, the stylish Suedehead had access to the previously out of bounds pleasures of the nightclub.

Like Ted Polhemus observed, there are two basic moves in street style, dress up or dress down. Suedeheads recovered the power of dressing up after the Mods had taken it all a bit too fancy dress for their liking back in the late 1960's. The Suedes drew heavily on their Mod heritage, with sta-prest, button down shirts and loafers - but the finished look was unique to the discerning eye. Suedes were known to wear smart tailoring - none of which were really 'Mod' styles. And their hair, just long enough to resemble Suede, was a world away from the Mod's continental inspired coiffs.

Given societies' relative lack of sophistication with regards to subcultures and their subtle lack of distinctions not visible to the untrained eye it seems like the hardest task for today's Suedehead would to explain to everyone in the pub that they are not a Mod.

TROJAN HORSES AND BOSS SOUNDS

Trojan Records were responsible for the army of ska and reggae stars that conquered the hearts and minds of British youth in the 1960's. While the mainstream was obsessing over clean cut white boys like The Beatles, the cool kids were going crazy for the new sounds of Jamaica.

Of all the record labels that imported Jamaican music to the UK - Trojan remains the most iconic. It was formed in 1967 as a subsidiary of Island Records to capitalise on the new popularity of Ska in Britain. While the Mods had dabbled in 'Blue Beat' it was the Skins who really adopted it as their sound - helping to make Trojan grow rapidly as a label. In spite of getting no radio play or press interest - Ska became a sensation.

Jamaica had a culture of sound systems. These were led by charismatic DJ figures who gave themselves majestic names and drove around the island in big trucks full of PA Speakers to organise parties. They were fiercely jealous of their best records, hiding them from their competitors. One Arthur 'Duke' Reid was a star of this soundsystem culture in Jamaica and his

truck (made in Croydon) was built by a British car manufacturer called Trojan. Hence, one of Reid's titles 'The Trojan King of Sounds'.

Trojan licensed many of Duke Reid's songs to release as 7 inches as well as many other Jamaican and British artists including legendary names like Lee Scratch Perry, Desmond Dekker, Jimmy Cliff, The Maytals, Judge Dread and many more.

Trojan was an icon to the 2-Tone Ska revivalists and the Trojan Logo is a symbol of the roots of the Skinhead culture, as much a part of the story as boots and braces.

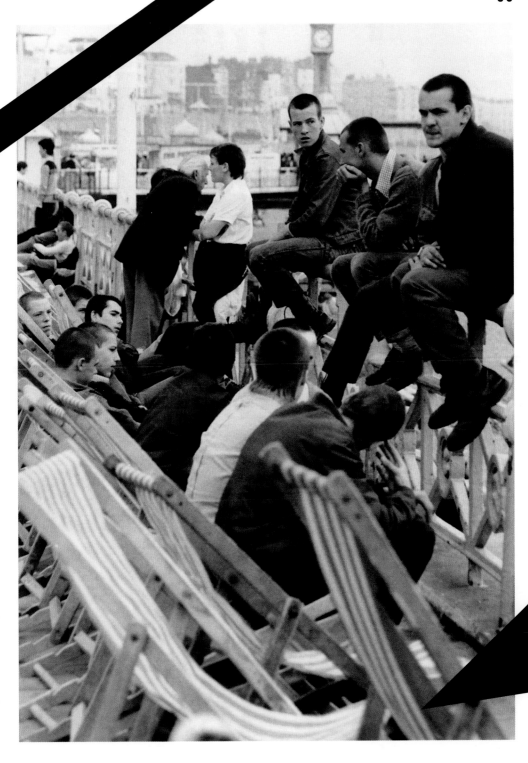

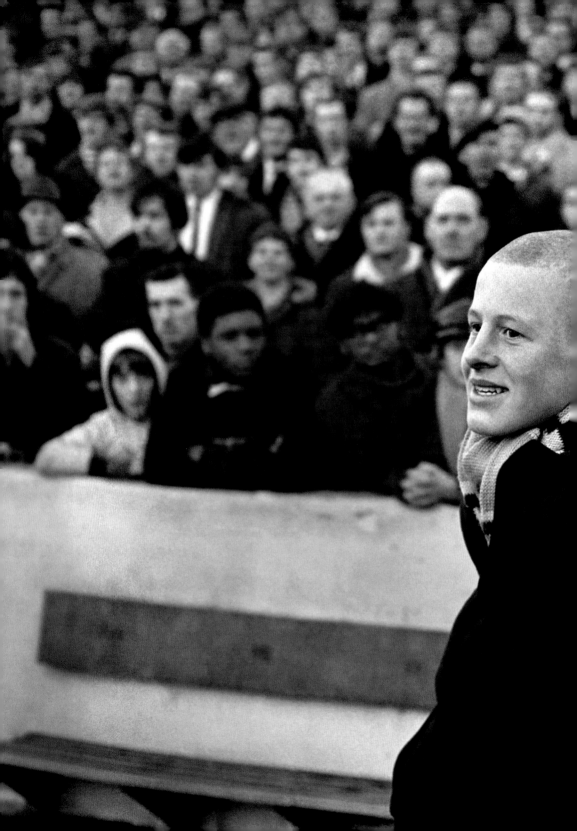

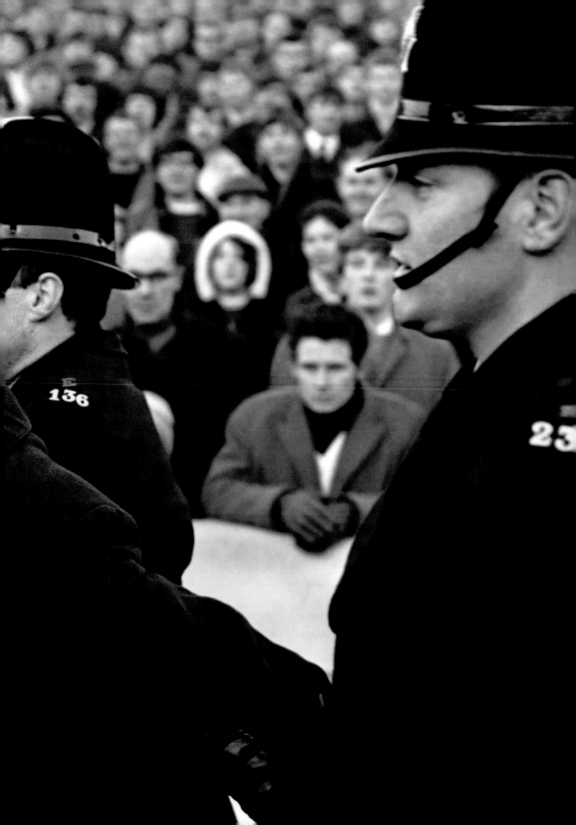

POLICE OPPRESSION

The relationship between Skins and the police has always been a wee bit tricky. Many of the Oi! bands recorded songs about police oppression, harassment and even police corruption. The Northumbria Police allegedly waged a campaign against the Angelic Upstarts in the early 1980's spurred on no doubt by the band's single 'Who Killed Liddle Towers'. But the use of the police as a stick to beat the workers with goes back a long way.

"The middle class expects help from the police, the working class expects trouble." (1973, Jackson cited in Clarke.)

There is the argument that the escalation of police presence makes violence more likely at any particular event. In the early 1970's football grounds ramped up the numbers of police in response to increasing panic in the press about Skinhead hooligans. This had a double edged effect - it increased the likelihood of a ruck and the capacity to arrest larger numbers of people. So maybe it was an element in the trend towards more violence and more arrests in 80's football?

It is an old truism of human behaviour that if you treat someone as if they are a threat, they tend to behave more threateningly. We mirror each other, or as one urchin put

it 'When you go raa in the mirror it goes raa back'. If you've ever walked past rows and rows of police riot vans, you'll have a sense of what it does to you. It puts you into a triggered state – it's only our human nature that kicks in and pushes us to either fight or flight. And the police are only human too – why wouldn't they find a big showdown exciting too. They're given to making provocative comments as well as overreacting when their blood is up.

At 60s and 70s football grounds the individual had the advantage of being in a crowd. When the police took action they could be jeered by thousands of voices. However, outside the stadium, the fans could be herded like sheep and humiliated, subject to piling their boots up and standing for an hour barefoot while home fans took the piss.

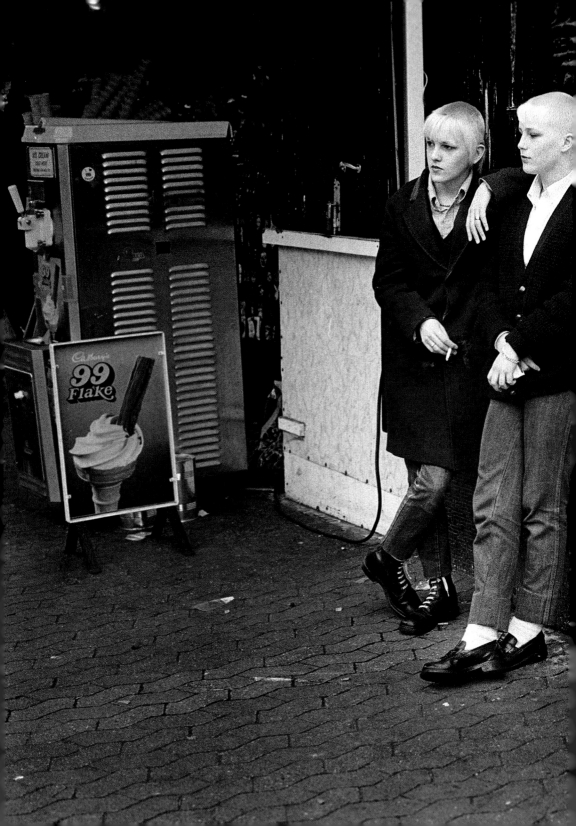

NOW SHOWING
2 HOUR SHOW

FOREVER BLOWING BUBBLES

The football terrace is the spiritual home of the Skinhead. Both Mod and Skin were London cults that were later distributed to the provinces. Mod was broadcast to small town Britain on the goggle box by 'Ready, Steady, Go!'. Skinhead was spread across the country by London football fans travelling to away games. Northern fans stood agape as armies of Millwall supporters dressed for war marched into their home grounds. Within weeks they were dressed just the same.

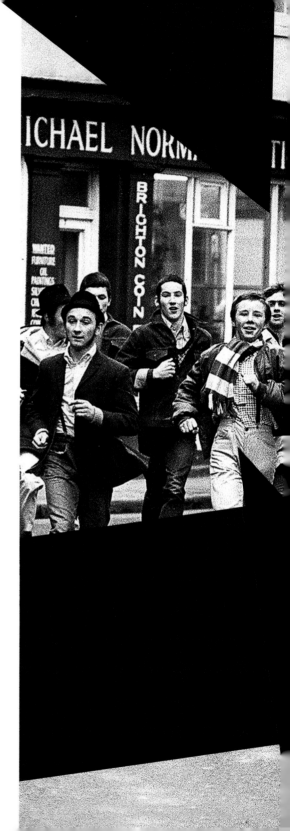

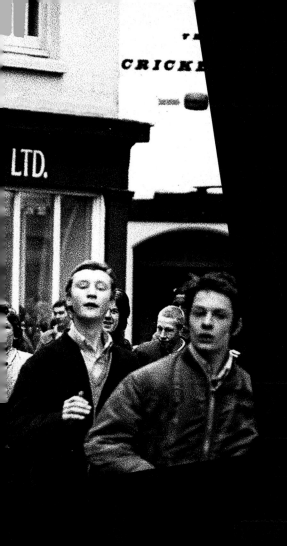

Skinhead style on the terraces developed alongside the increasingly organised violence between supporters that took place before, during and after the match. For young lads in search of excitement, hooliganism was cheap, readily available and more thrilling than a week of bank holidays in Great Yarmouth. It allowed Skins to feel like they were representing their area on a bigger stage. The more trouble they caused, the more glory for the reputation of their team town or city.

During the week they might scrap with local Skinhead gangs in turf wars - on Saturday all local grievances were forgotten as the Skinhead crews came together to represent their teams be it West Ham, Newcastle or Millwall. The same went for international level games or tournaments, when all firms would come together to represent their home nation in a way that many would prefer they did not.

The 1970's and 1980's were the golden age of British football violence. From the late 1960's it became more common to go to away games - and then the tradition of trying to take the home supporters end of the ground was born. By the late 1980's firms were well organised and well travelled - causing controversy in Europe and beyond. Skinheads gave way to Casuals as the football hooligans style tribe of choice.

Right: Fans are frisked and their boots checked for steel toe caps by a police officer before the Chelsea v Arsenal league game at Stamford Bridge, 27th May 1969.

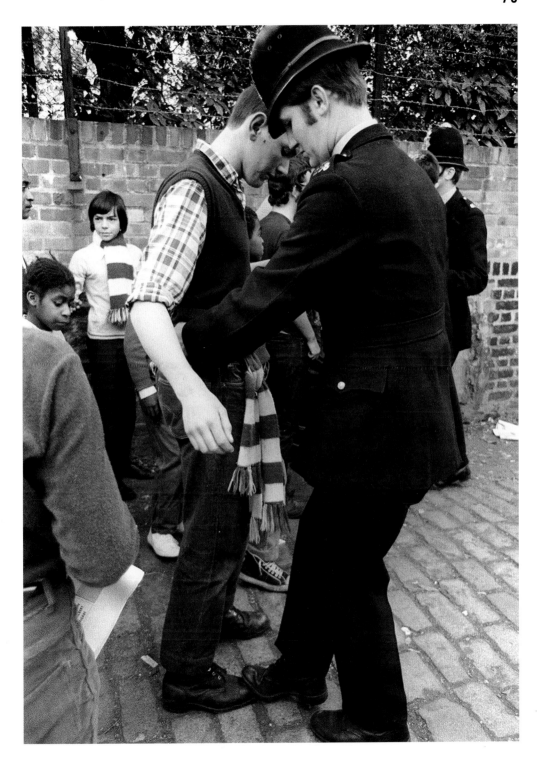

The connection between Skinhead and football was still strong in the 1980's however, with the Cockney Rejects using their band as a vehicle to promote the glories of West Ham to the nation. They even recorded West Ham's anthem 'Forever Blowing Bubbles' in 1980 and wore Hammers colours on stage. This brave but foolhardy position ended in many gigs becoming pitched battles when the local Skins, and rival firms, came to see them play.

Eventually football was gentrified, and the old working class hard man was given no place in Tony Blair's classless 1990's. Suddenly every student and posh boy in the country supported Manchester United. Now you can buy smashed avocado on sourdough toast and artesanal craft beers at football stadiums. Gone are the mass of weekend warriors standing shoulder to shoulder on the terraces looking for a ruck. Gone are the Kop and the Shed proper. It's pretty much all seated now.

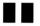

"I look upon the original skinhead subculture as being the last great working class subculture."

Hand in Glove, Blog

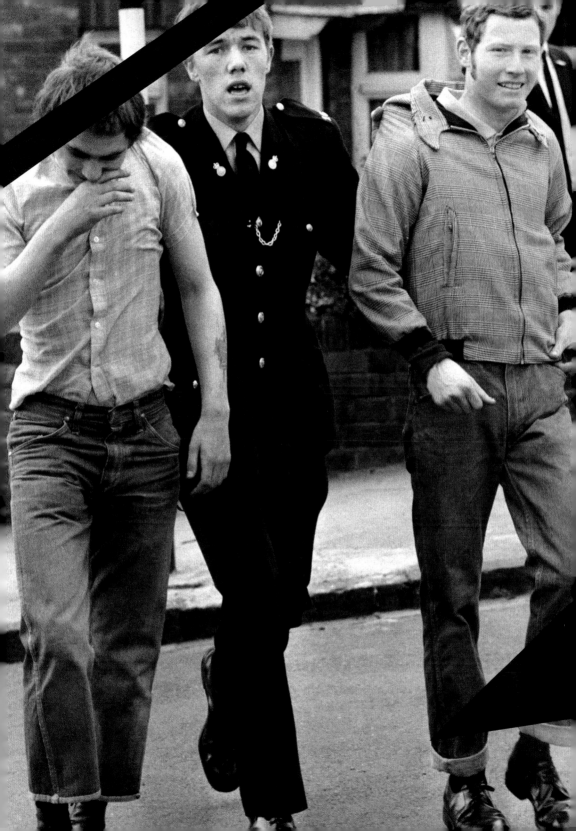

LAW OF THE JUNGLE

The Skinhead and his natural enemies.

Student Lefties

Incredibly earnest, well spoken young men and women from London's finest universities must have seemed absurd to the point of tragedy when they came down to the worker's cafes after the factories kicked out to try and persuade them to join in their socialist revolution.

The student uprisings of 1968 fell apart when the young lefties came face to face with the workers and realised they had absolutely nothing to say to each other. Skinheads saw them as privileged kids playing politics before they took that job in the city with daddy. History largely proved them right in this suspicion.

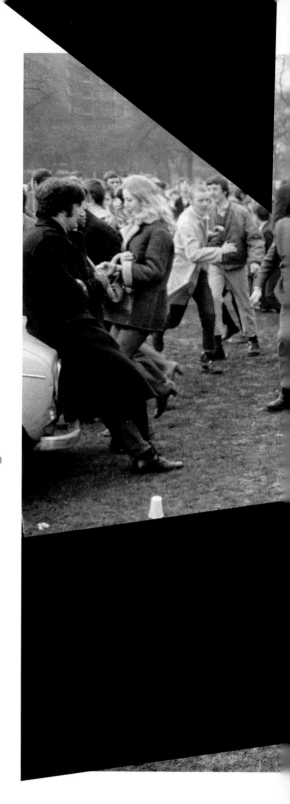

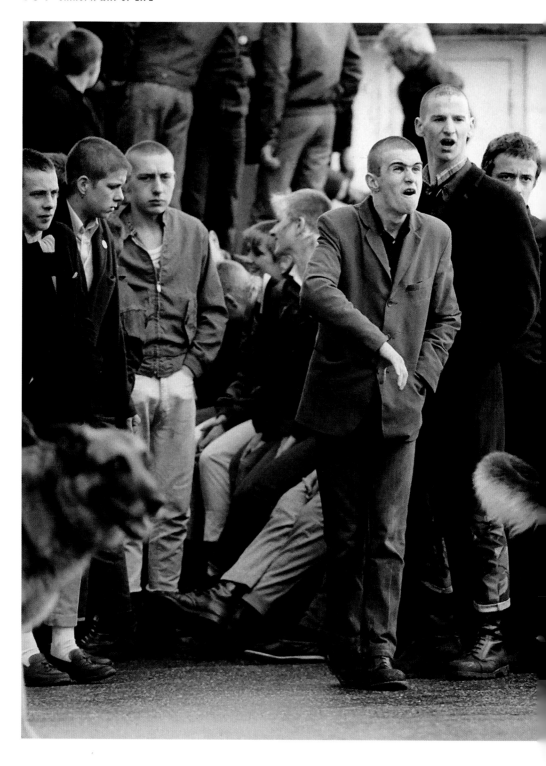

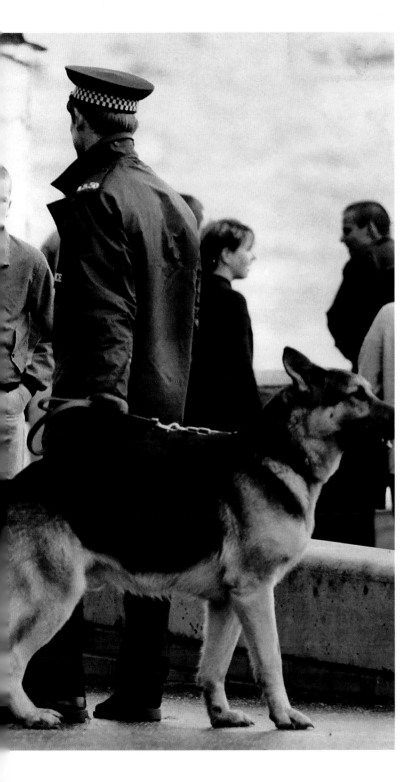

Southend Bank
Holiday 1981.

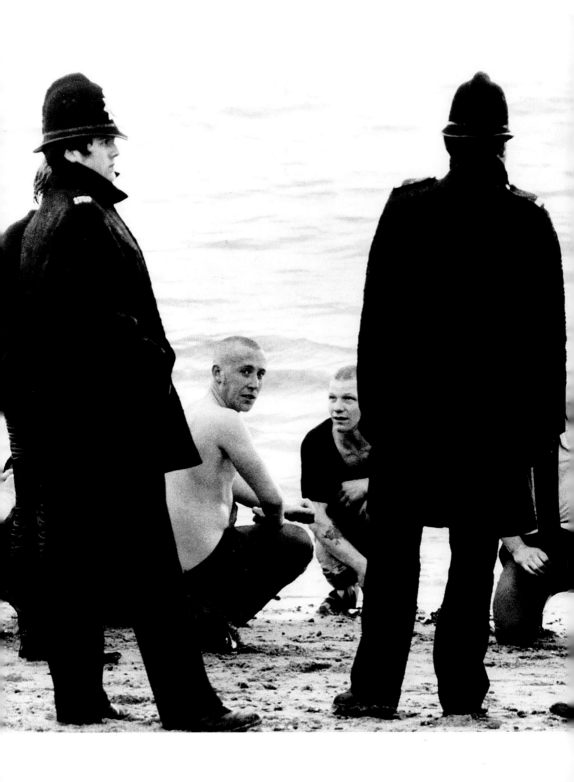

Hippies

Peace? I loathe the word. Hippies aggravated all the most fundamental Skinhead values. They were scruffy, dirty, spaced out and clownish. They didn't take themselves seriously, no self-respect. And most of them were just in it for the sex and drugs. Dropping out of society was obviously a privileged self-indulgence. Nobody who had to fear genuine poverty would walk away from a proper job. And they were only too happy to scrounge off the state - another sore point for the Skins who believed in working for a living.

Other Skinheads

Hard young men generally prefer to fight other young hard men. And territorial squabbling most likely made up 90% of a teenage Skinheads diet of violence. Finding reasons for aggro with other Skinhead gangs was easy - and there were fewer consequences involved. Middle class kids call the police. Other Skins might take a beating, give a beating, say no more about it. In the second wave of Skinhead culture - Skins also fought over politics, football and stylistic differences.

Squares

Annoying landlords, shopkeepers, park keepers, teachers and whoever else might have a scrap of authority has always been the best game in town for delinquent kids on a mission to make memories. When you are barred, bored and broke how else are you going to rustle up a bit of bovver?

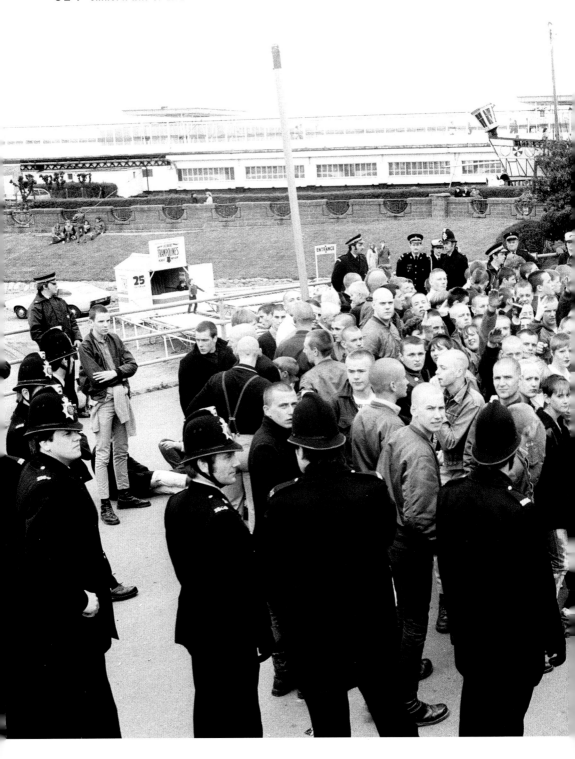

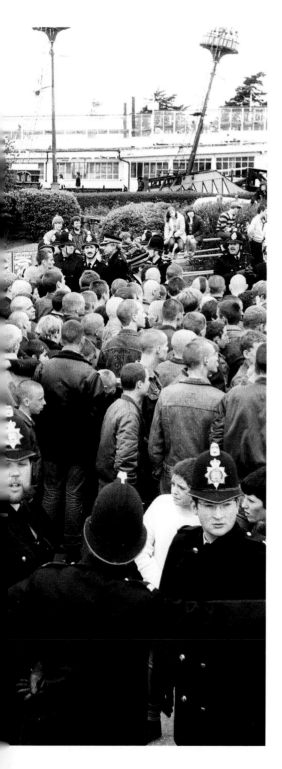

Brick a few windows. Kick in a few toilets. A bit of football graffiti. Walking over the bonnets of a row of parked cars. We've all been there.

The Filth

Back in the 1970's it was not considered a scandal for coppers to give a lad a 'going over' in the back of the van. Skins were such an obvious target for the police it is no wonder they developed a mutual dislike. The fuzz confiscated bootlaces, or even forced Skinhead fans to remove boots completely at away games. Oi! gigs often attracted a police presence - especially the Angelic Upstarts who had aggravated the Police with the song 'The Murder of Liddle Towers'.

Your Mum

Joe Hawkins fears only one thing. His mum. You don't want a cockney duchess coming after you for the wrong reasons. So you best put that fiver back in her purse. On the upside, if any of your enemies come to pay you a little visit, she'll have their bollocks off with a carving knife.

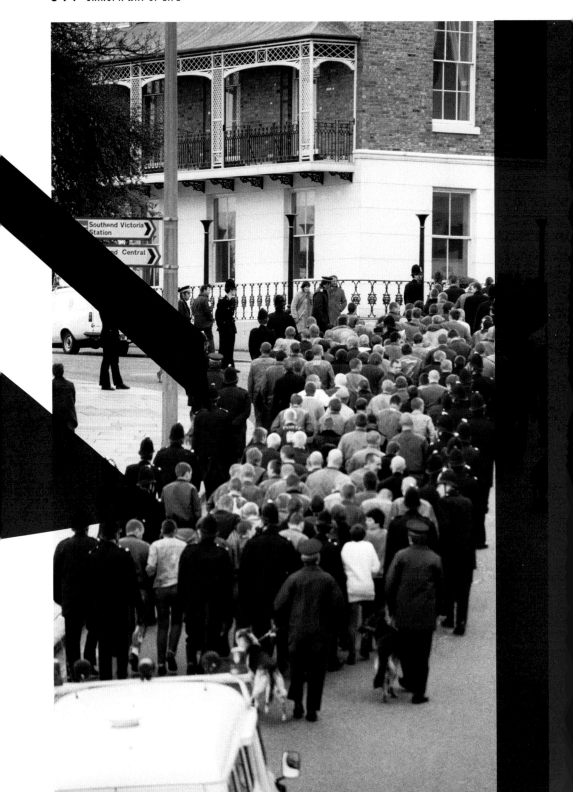

HE'S JUST A STEREOTYPE

When the Specials sang about the guy who drinks his age in pints back in 1980, the Skinhead stereotype was already firmly established in the public eye. He was a barely evolved shaven ape, a macho alcoholic too stupid to hold any credible views, addicted to the extreme sensations of sex and violence.

Loathed by the left for being so conservative, despised by the right for being so disorderly - dumb enough to doff his cap to the Queen and yet rebellious enough to tell a copper to fuck off. He didn't fit. He was lower than low. And for many that stereotype still holds water.

So are Skins stupid? Do me a favour. It takes intelligence to adopt a subcultural position. People who don't think about life and their place in it - don't tend to associate with youth cults. You have to have a certain curiosity, a certain courage, a level of critical engagement with the world around you to see the value in adopting such a controversial style. It is not popular, it was never cool. For a brief moment in the 60's and a brief moment in the late 70's you might have got swept up in the Skinhead crowd - but only if you grew up in very specific urban areas. You have to really want to be a Skin - that shows self-direction and choice.

"I know Skins who went on to be professionals, business owners, craftsmen, soldiers and the like. Everyone went in a myriad of directions. I still laugh at the thought of the two that went on to be chemists though".

80s' Skin.

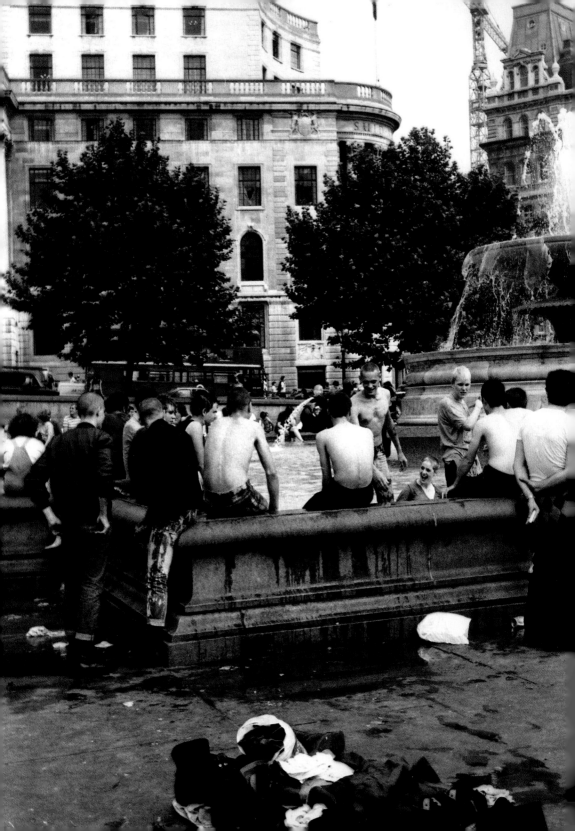

Are Skins macho? If you want to criticise youth cults for having conservative gender roles you could just as easily look at any other style tribe. Today the liberal media falls over itself to eulogise misunderstood rappers who are misogynist. Skinhead women come from traditional working class backgrounds, but they subvert traditional gender expectations, wearing androgynous styles and playing rough. The original Skins were from another era and their gender politics belong to the 1960's – Skins today are very different.

The violence is a complicated issue - the point perhaps being that middle class kids don't fight because they don't need to - the whole system is on their side. The only sensible response to passive aggression - is aggression. In any case - Skinhead violence has always been much bigger in the imagination than in the real world. So maybe Skins are macho - but sometimes it is better to be too hard than too soft.

So are Skins right wing? Loads of voices from within the scene say no. Skinheads who joined right wing groups or gave Nazi salutes at gigs were always in the minority in the UK. They were young, confused and manipulated by older NF organisers. With few exceptions most grew out of the fascist ideology as they matured. Today, rather than Skinheads gravitating to fascism, fascists worldwide adopt a 'bonehead' style which has much more to do with looking scary than it does to do with Skinhead traditions. It is a much more militaristic style than the UK Skins ever wore. It seems fair to classify it as a separate culture entirely.

The Redskins were an example of Skins who were firmly Socialist in their outlook. They inspired a lot of left wing Skinheads and helped to support the Miners strikes in the mid-1980's. These were working class guys from York who were thoughtful and well-read, name dropping figures from socialist history in their interviews - having opinions on Trotsky. They had a handle on Marxist economics - self-taught. They were members of the SWP and they were revolutionary socialists - all of which is deeply unfashionable now for better or worse - but you can't accuse them of being shaven apes. They had brains.

A lot of intelligent and interesting people followed the Skinhead subculture. Steve Jones and Paul Cook of the Sex Pistols, Suggs from Madness, Jerry Dammers of the Specials, Kevin Rowland of Dexys Midnight Runners. Morrissey flirted with Skinhead imagery, go figure.

Hoxton Tom McCourt was another fascinating figure of the Skin revival who had a huge impact on the survival of original Skinhead and Suedehead style - another intelligent working class guy with a nuanced political stance who fought against hard-left and hard-right incursions into his scene.

In the movies, director Shane Meadows explored his own complicated relationship to Skin culture with 'This is England'. The movie brilliantly depicts a group of carefree Skinhead teenagers growing up. The film accurately mirrors real life as things naturally get harder and more complicated for the characters involved.

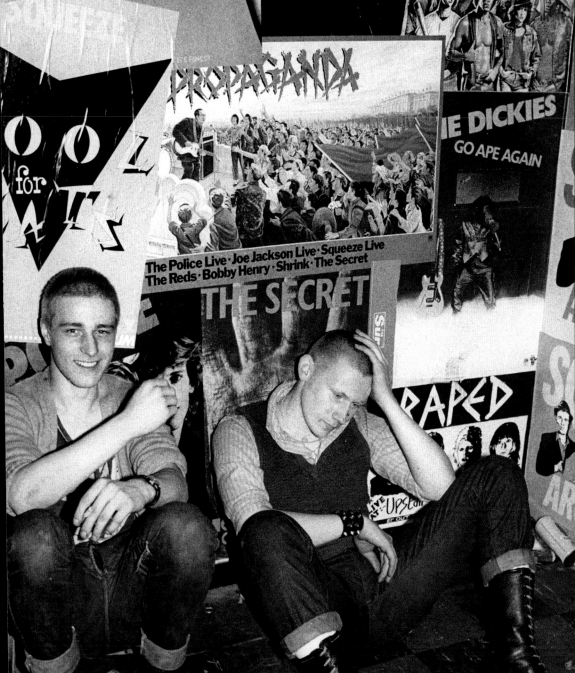

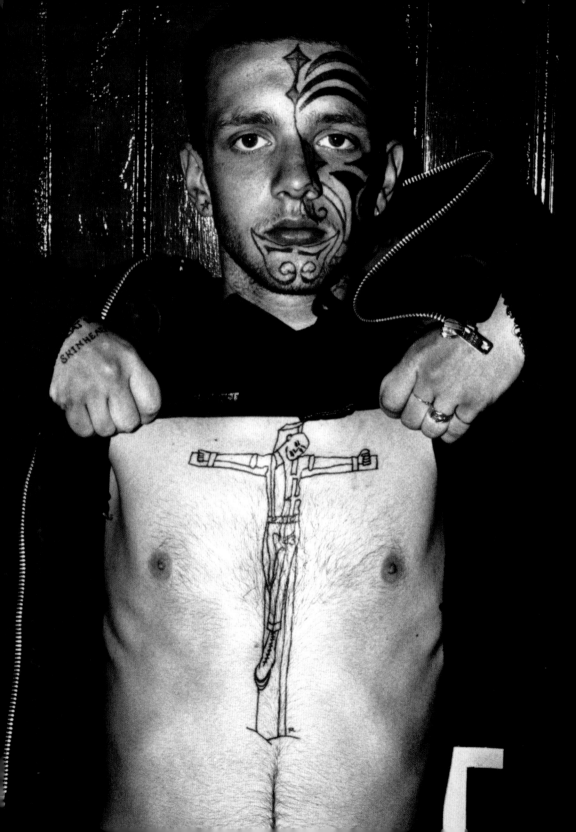

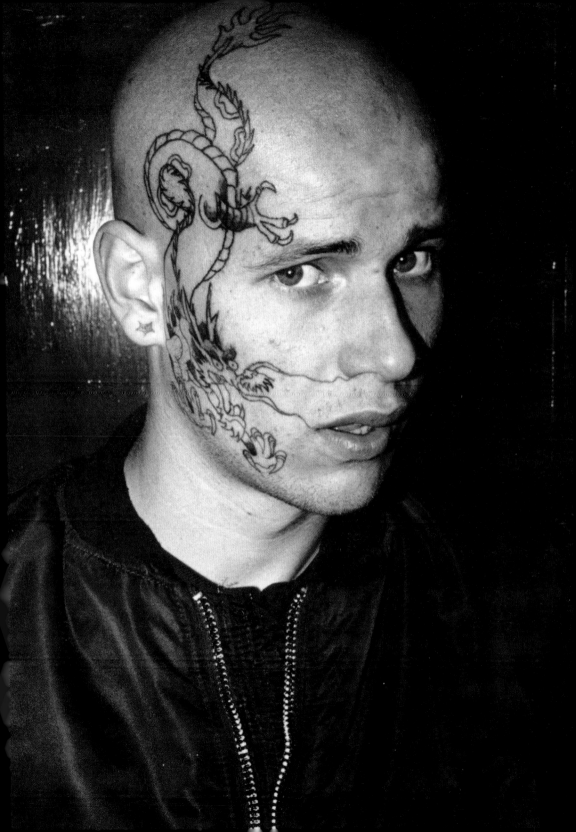

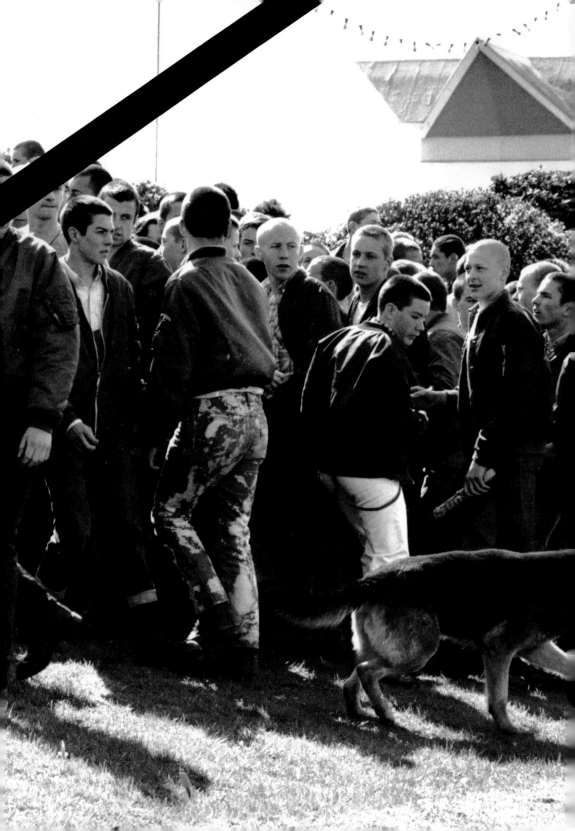

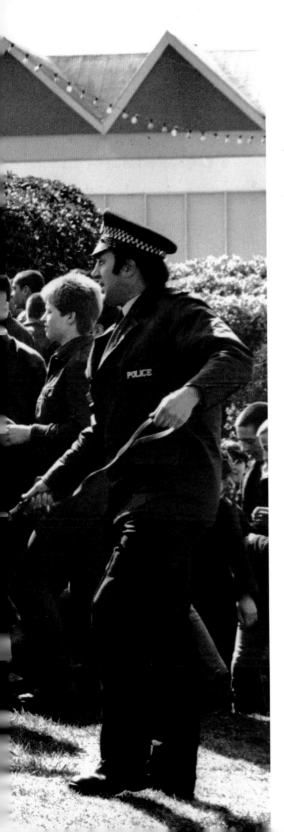

Tim Roth kicked off his movie career with a critically acclaimed Skinhead role in Alan Clarke's 'Made in Britain'. Trevor, his character, is a furious young man getting dragged through the old social safety net backwards. A racist who's best friend is black. The film shows with detailed realism what happens to a kid who falls off the bottom rung of the ladder in 1980's England.

In 1986 even the liberal media seemed to admit that there was more to the Skinhead than the stereotype. The Guardian released it's famous advert where a young man dressed in classic Oi! style, the very chap who only five years before was being crucified. He runs toward a city gent, apparently in order to mug him, but at the last minute the camera switches viewpoint and we realise that the Skinhead is saving the man from, of all things, a falling piano.

Talking to Skins around the world in his documentary 'World of Skinhead' (1995), George Marshall found that, all joking aside, Skins just want you to look twice. See past the bullshit. Judge them on their words and deeds, not on some vague idea you got from watching American History X. In other words, don't pre-judge. Because prejudice is bad innit?

SKINHEAD PULP FRICTION

In the late 1960's Britain was in a state of full blown
moral panic about the state of the nation's youth.
Media coverage of the decline in character of 'young
people today' was everywhere. The Mods and the
Rockers seafront shenanigans had created a strong
link in the public mind between deviant behaviour and
youth style tribes. Alongside all the moral crusading
and sucking of teeth - there was the murky fascination.
Respectable people could get their kicks reading lurid
pulp fiction written to cash in on the new scenes.

"Skinhead" by Richard Allen was released
in 1970. And while Trojan Skinheads sort
of disappeared in London at this time - the
style of dress was perpetuated on the
terraces. In the 1970's, the new generation
of Skins would not get their sub-cultural
lessons from the reggae loving bootboys
of London - they would get them from
Richard Allen.

James Moffat was a boozy middle aged
hack writing penny dreadfuls by the
bucketload under various pen names.
As Richard Allen he created his most
enduring character 'Joe Hawkins' an
unrepentant Skinhead psychopath who
wouldn't know Prince Buster from Adam
and the Ants. Hawkins lives for trouble
and is constantly bullying his reluctant
crew into starting fights that almost always

seem to end with someone being kicked
repeatedly in the bollocks. It is amazing
they find time to sexually satisfy so many
middle aged women not to mention the
rape scenes.

'Skinhead' had an impact on the culture,
firmly identifying a racist outlook with the
style and emphasising football violence
over any music or dancehall aspect
of the Skinhead life. It was a cartoon
interspersed with Moffat's raging and
confused social commentary - often
unintentionally hilarious, with much sexual
fantasising and titillation thrown in for
good measure.

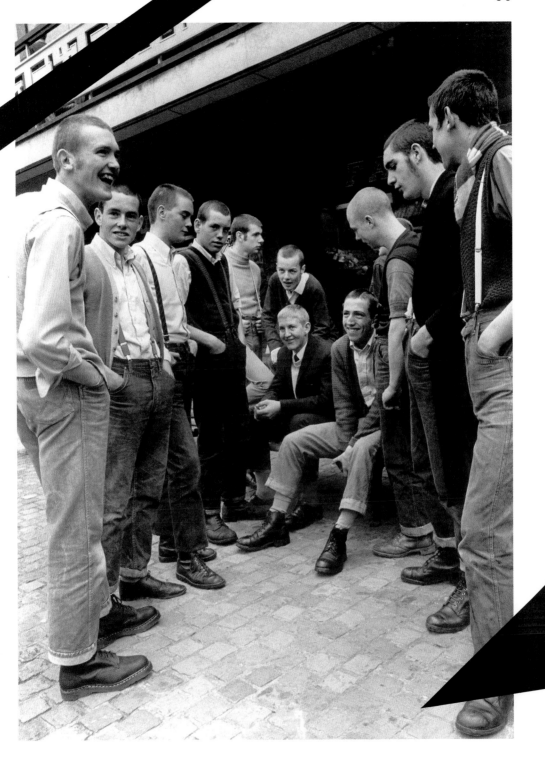

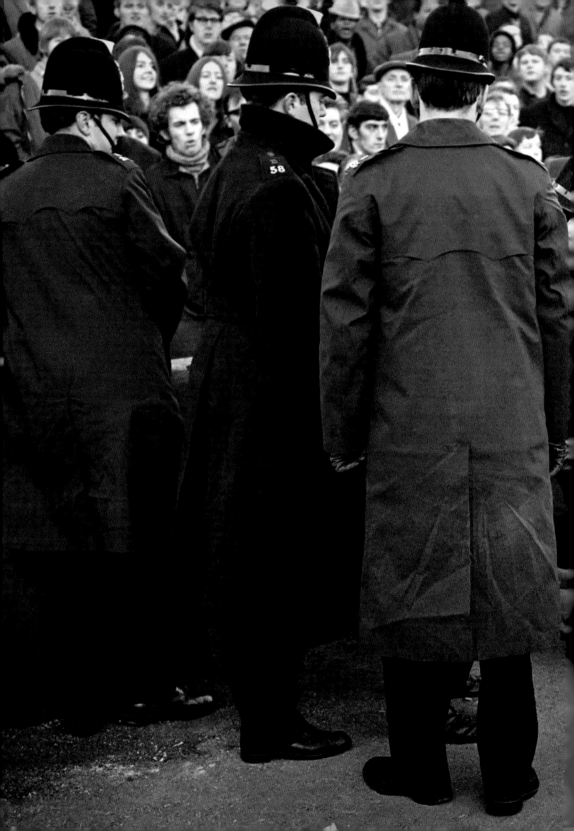

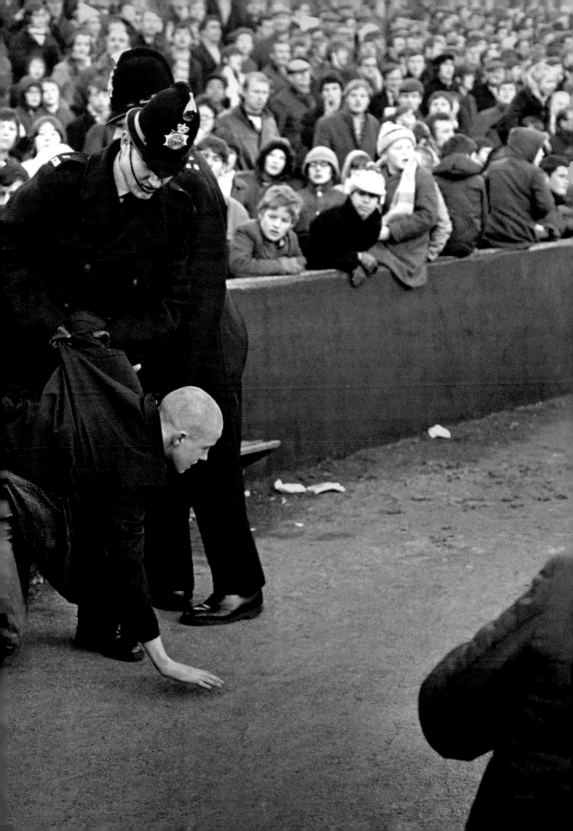

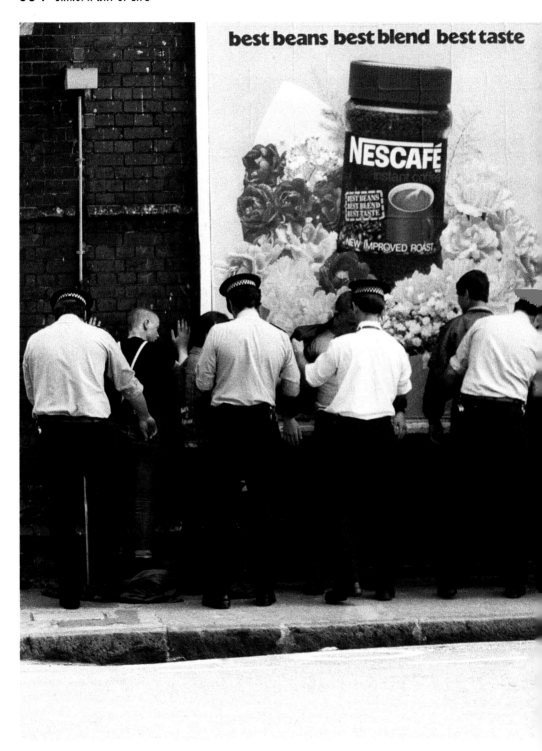

Joe Hawkins is a racist, but by his own admission it isn't about colour - he just hates everyone. The only thing he wants out of life, aged 16, is a series of violently intense and intensely violent experiences. He is not political - you wouldn't catch him at an Oswald Mosely gig. He is simply a cardboard-cutout folk devil - designed to outrage your dad and possibly get your mam feeling horny.

Like all moral panic - "Skinhead" exaggerated the reality. And just as the panic about Mods and Rockers peaked the very moment the cultures disapeared - Skinhead pulp fiction had it's moment in the sun while the original Skins started growing their hair and going to see Slade. It wasn't until later in the decade that the first major Skinhead revival would appear.

▋▋

"Without his boots he was part of the common herd. Joe was proud of his boots. His were genuine army-disposal boots; thick-soled, studded, heavy to wear and heavy to feel if slammed in a rib."

Joe Hawkins, Skinhead by Richard Allen. Published by Dean Street Press

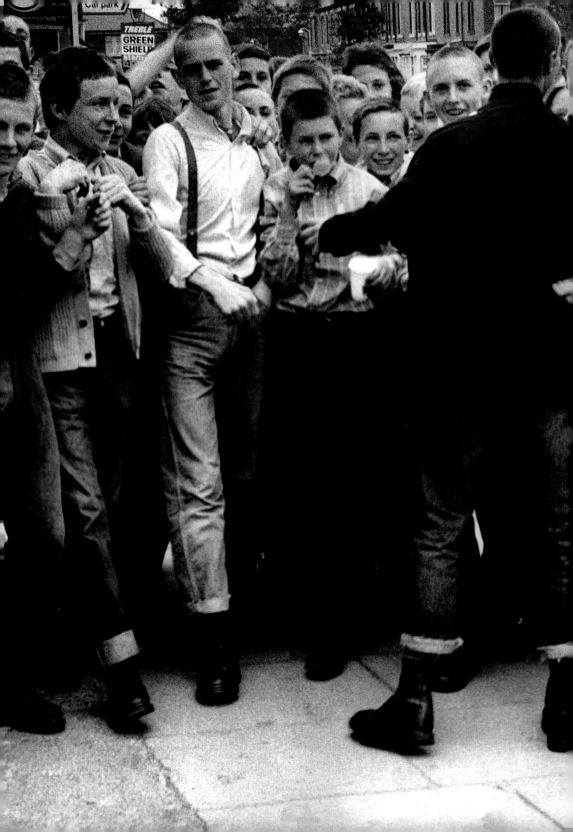

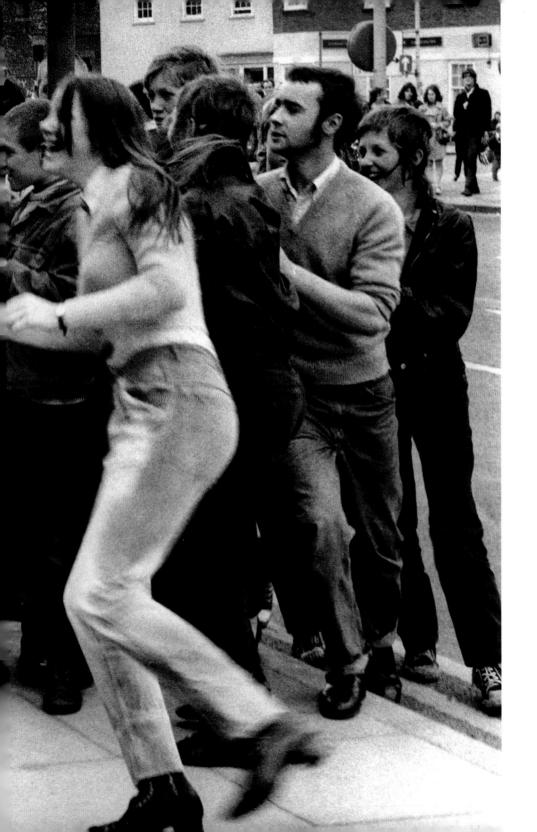

SKINHEAD EL DIABLO

In the 1980's, Skinhead was the devil and the tabloid press were the witch hunters. Along with other horrors like the IRA gunman and the single mother - Skinheads were made into a cartoonish abstraction designed to titillate, terrify and sell papers. They were the 'Yobs' of countless headlines. They gave a recognisable face to the age old problem of delinquent working class youth.

Skinhead the devil was at turns a mugger of old ladies, a glue sniffer, a football hooligan, a vandal, a racist thug, a hater of women, a queer basher and the village idiot. The style was reduced to the haircut and the boots. Skinhead became a blank canvas for generalised fears and anxieties about the state of the nation. Despised by liberals and conservatives alike - this particular folk devil seemed to unite people in their loathing. In the movie 'La Haine' the main characters consider murdering a Skinhead because 'Why not? Everybody hates Skinheads.'

Most of the youth tribes of the 20th century have long since been rehabilitated and warmly accepted by wider society. We live in a liberal moment where baby boomers are at the controls of society, going home to listen to the White Album and perhaps do a cheeky spliff with their Chardonnay at the weekend. Mods, Hippies, Punks - they've all lost their edge. But Skinheads remain resolutely difficult.

They're not liberals. They don't aspire. They see through all the self-serving grieving. Worst of all, they won't join your movement - left or right.

But Skins are no longer a true folk devil. They have been replaced by hoodies. When David Cameron made his 'Hug a Hoodie' speech in 2006 there was a huge degree of hype about anti-social behaviour in the press. This reached its apogee in the 2011 London riots. Today, the press is strangely quiet on antisocial behaviour - is it that after the Grenfell Fire nobody wants to rush to demonise the urban poor?

Terrorism too has changed the way we think about wayward youth. The Islamic terrorist has become such a powerful folk devil that tales of juvenile delinquency don't seem to have the same currency as they did in the 1980's. When you can watch a live decapitation on YouTube, kicking a bus stop in just doesn't cut it anymore.

Can the devil ever be redeemed?

Just maybe the Spirit of '69 is the antidote to these troubled times. Be authentic, be proud of who you are and where you are from but also open to inspiration from other cultures. Be brave, fight your corner, see through all the bullshit.

We're a mongrel breed after all.

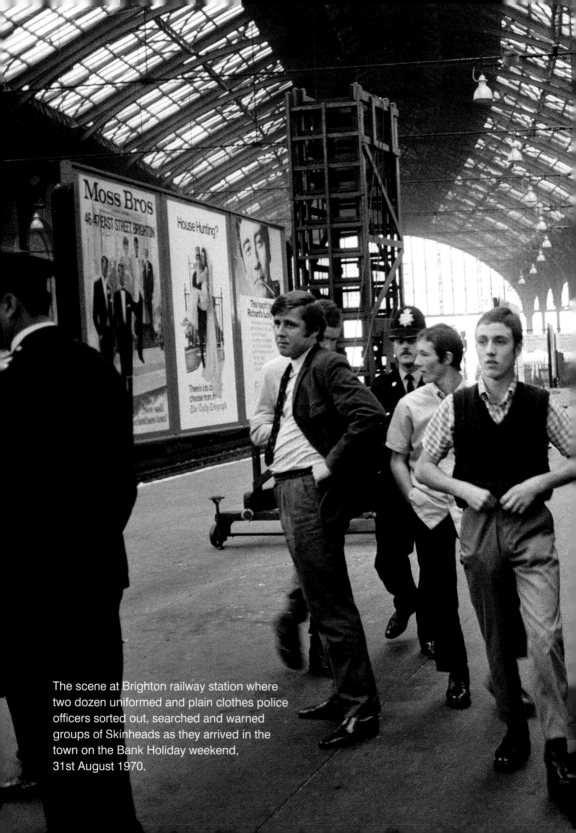

The scene at Brighton railway station where two dozen uniformed and plain clothes police officers sorted out, searched and warned groups of Skinheads as they arrived in the town on the Bank Holiday weekend, 31st August 1970.

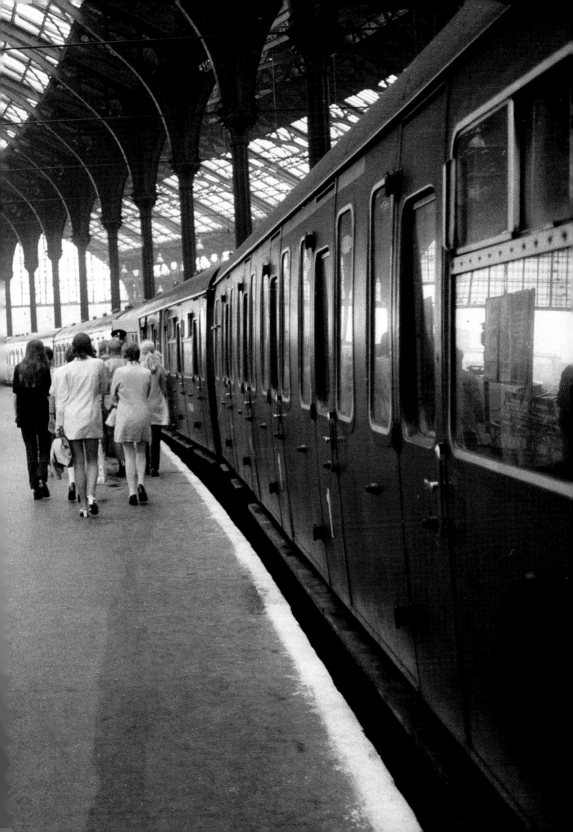

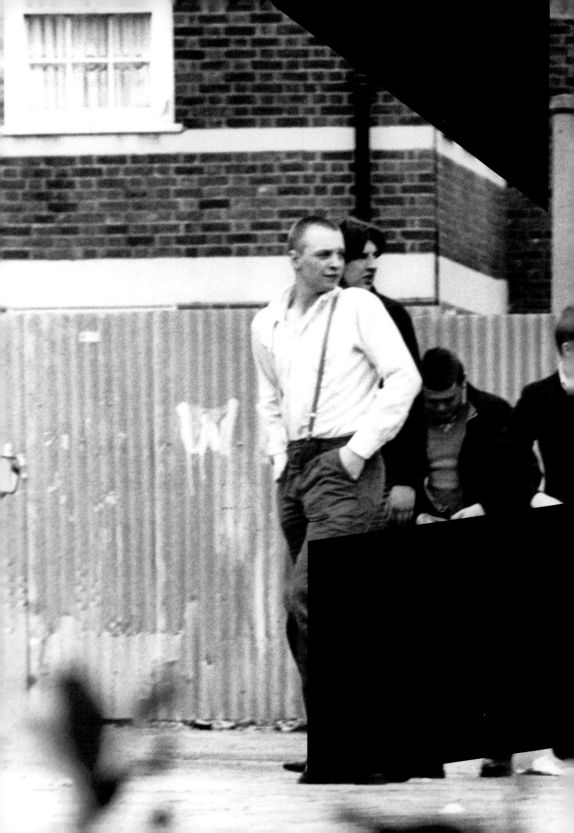

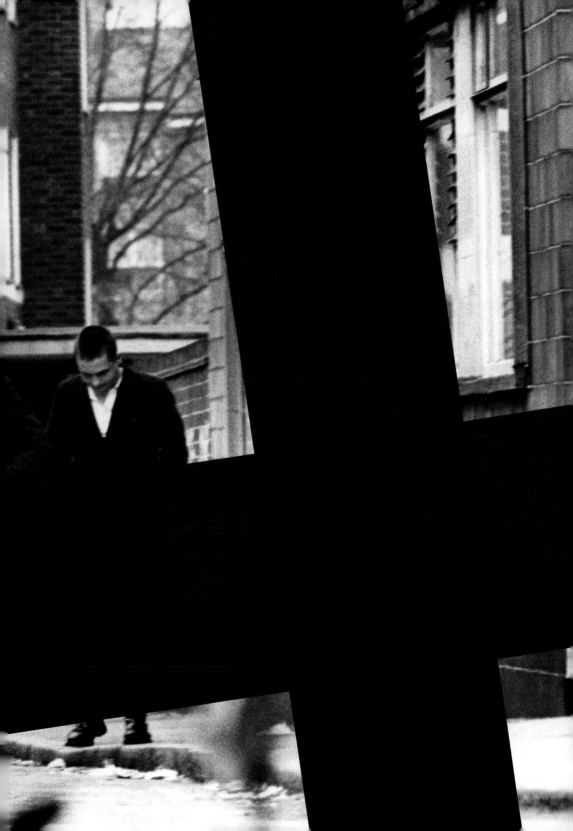

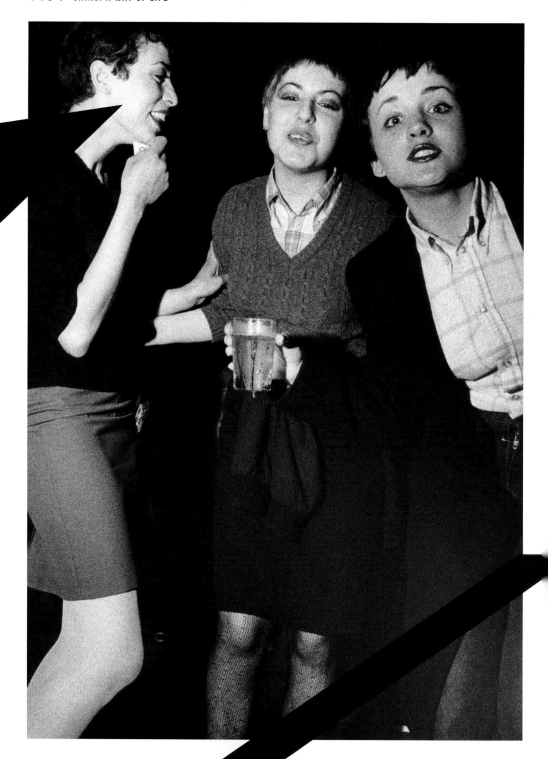

FEATHER CUT: SKINHEAD GIRLS

Skin girls never got as much press as the boys, but they were an integral part of the Skin story. Richard Allen wrote a lurid penny dreadful about them in 'Skinhead Girls', showing that they were just as exciting to mainstream society as the boys were. Alan Mead published a photo book about them in 1988. Also titled 'Skinhead Girls' it's now a prized collectors item.

Like Symarip sang on 'Skinhead Girl' (seeing a theme?) the boys loved them because they were the same weight, height and size and they looked just like them! Almost every Oi! band you can name has done a 'Skinhead Girl'. Not wanting to miss out on using the imaginative title, the re-formed Specials released a whole album called 'Skinhead Girl' in 2000, a covers album of Trojan Records songs.

Rude girls were not your average princess waiting to be rescued, they could drink and fight with the best of them. But they weren't quite as mental as Punks. Gill Soper recalls the moment all her friends got bored of Punk shenanigans and dropped it for the tighter Skinhead revival. Life moves fast when you're young.

*Skinheads were more structured, not
so wild. We wore smart clothes, we had
perfect hair and nails...*Carrie Kirkpatrick,
Interviewed by Anita Corbin, The Guardian,
2017

Just like the boys, there are distinct
variations of the Skin girl style. They can
be broadly divided into Mod influenced
Skins and Punk influenced Skins. The
former looking more like Mod girls, the
latter looking punkier. They often dressed
in an androgynous style, a hard edged
look with some feminine touches like
classic '60's dark eyeliner. They could
wear almost the same wardrobe as their
male counterparts.

■■

"Skin Byrd; a female belonging to the
Skinhead subculture. The Skin Girl as
they are also called, holds the same
values of her own Skinhead sect as her
male counterparts. She dresses very
similar to Skinhead men, but she often
wears short jeans or twill skirts. Skin
birds sport a hairstyle called a Chelsea
or a Feather Cut".

Urban Dictionary

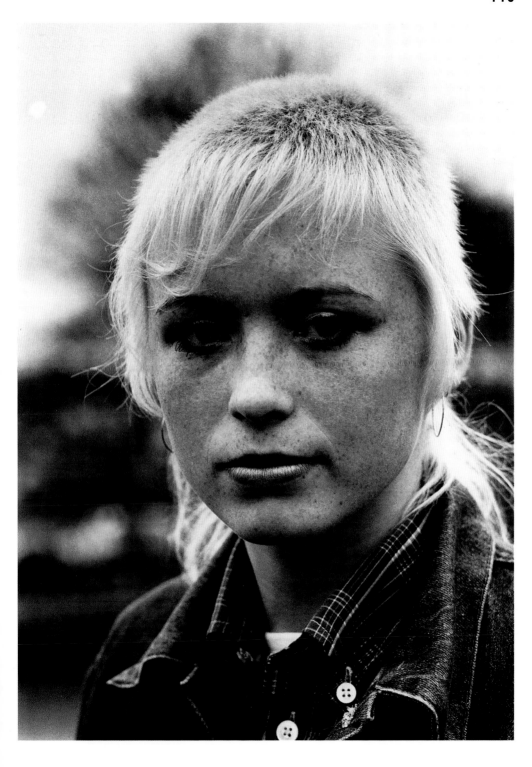

"We were as fearless as the boys and better dressed with it. There was nowhere we wouldn't go, Scarborough, Blackpool, football, gigs. They may not have acknowledged it but we were their equal".

Skin Girl

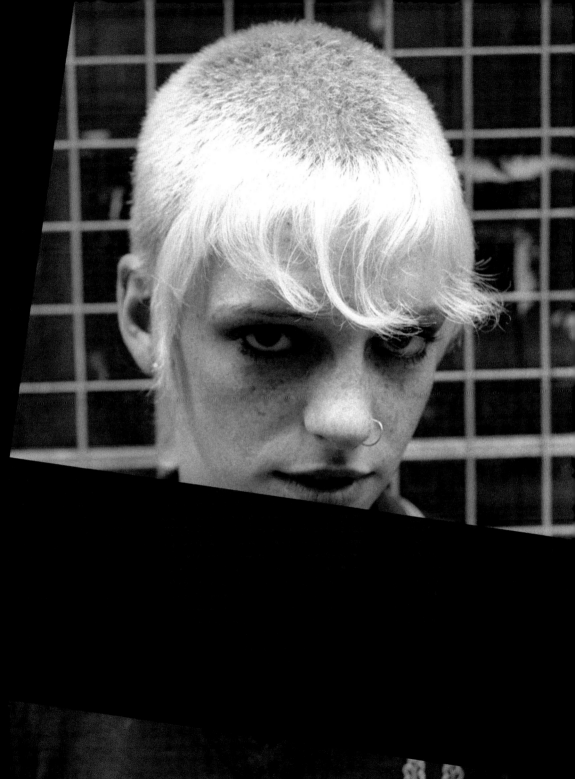

Both the ex-Skinhead women interviewed in the Guardian piece recalled the smartness of the Skinhead look, mentioning getting suits tailored and buying shirts. Again this shows how closely linked the traditional Skin and the Mod cults were - even if they regarded each other as enemy tribes at the time. Many kids of the late 1970's went from one scene to another and back again. As these particular Skin girls got older, they got into Northern Soul. Today, Skins and Mods can often be found at the same events.

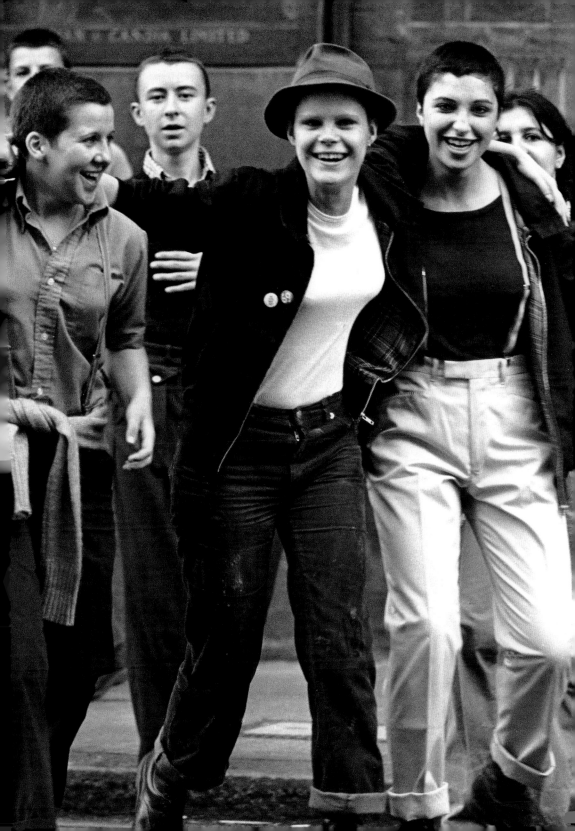

SUEDEHEADS AND SMOOTHES

As the impossibly young Skinheads grew up and found work, some of them evolved a new style to go with their new cash flow. The Suedehead, so called because he grew his crop just long enough to pull a comb through it, was a sharper dressing version of the Skinhead. He could afford a Crombie overcoat, though it may have been a knock-off version. London Suedeheads topped the Crombie off with a silk pocket square. The Suedehead spent a lot more time in a suit. He was not shy of a nice sheepskin, suit jacket or a wool cardigan. Ben Sherman shirt with Tank Top and Sta-Prest trousers in a green and blue 2-Tone fabric was a common look.

John Simons was the fashion retailer where any young Suede worth their salt would make a pilgrimage to get their hands on exclusive American tailoring. Simons is famous for christening the 'Harrington'. After displaying a G9 golfing jacket with Fraser tartan lining and elasticated cuffs in the window of his Richmond shop he added a handwritten note that explained: 'often worn by Rodney Harrington', (a character played by Ryan O'Neal in the US drama Peyton Place). Hey presto! The Harrington was born.

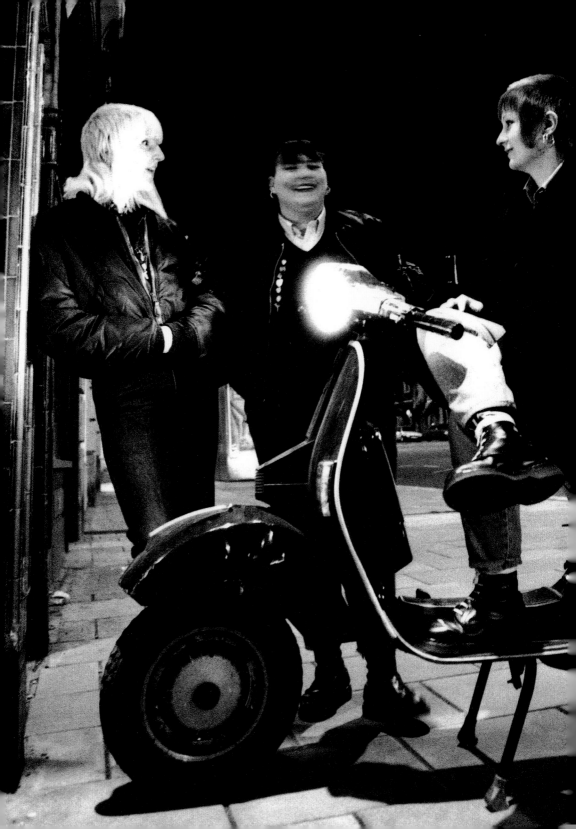

Suedehead women were known as Sorts. Again they wore an elevated version of Skin girl style. They had access to everything the boys wore, such as Crombies, Ben Shermans and sheepskins but they also had women's suits, smart skirts and dresses. Like the men they could wear the wide collars that were popular in the 1970's and a wider range of fabric prints than the original Skins went for.

Richard Allen's second book in the Joe Hawkin's saga saw Hawkins evolve into a Suedehead. Allen painted this out as a full scale rejection of his working class roots in the East-End as Hawkins crosses town to the West End to get a white collar job and a slice of respectability. For Allen, this is all a front - giving Hawkins a good cover for carrying on his sociopathic merriments. The Suedehead is still the vicious thug from Skinhead, he just wears a Bowler Hat carries an umbrella with a sharpened tip. Interestingly, Alex in 'A Clockwork Orange' appears with his Bowler Hat and Umbrella a year after Suedehead was published. Did Kubrick read it?

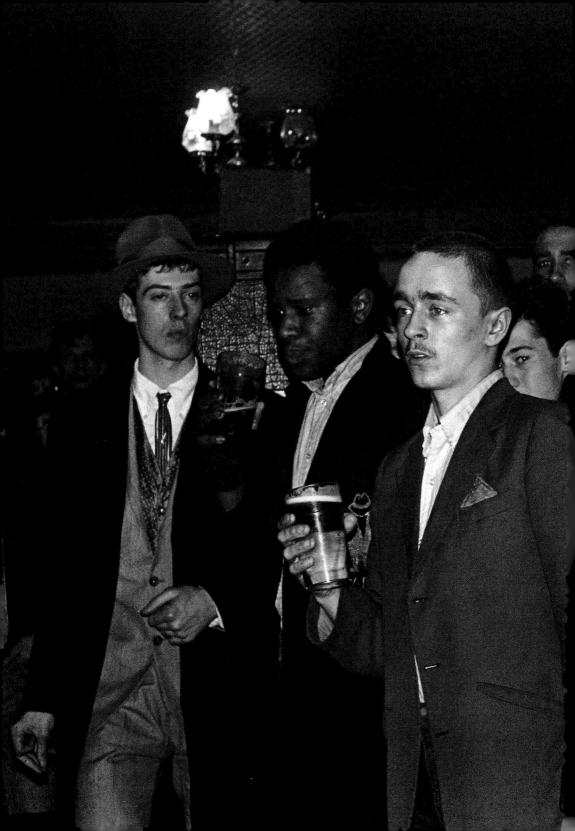

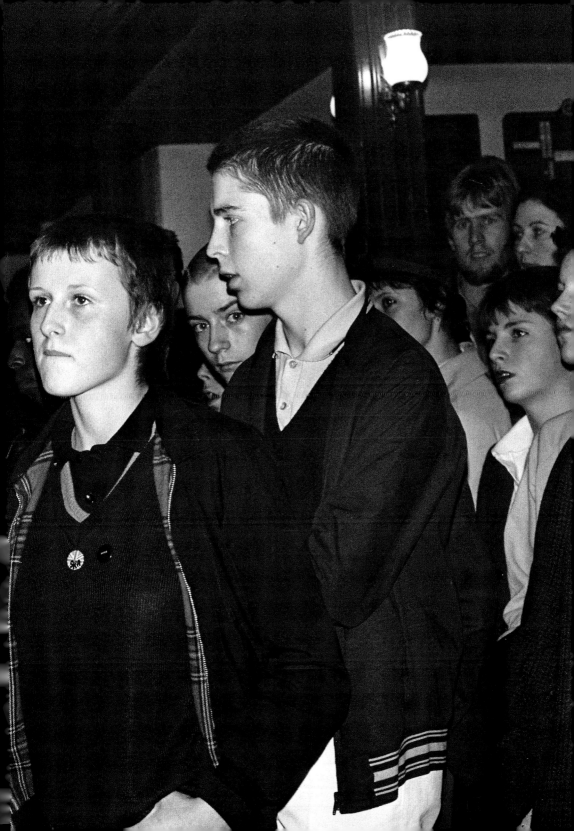

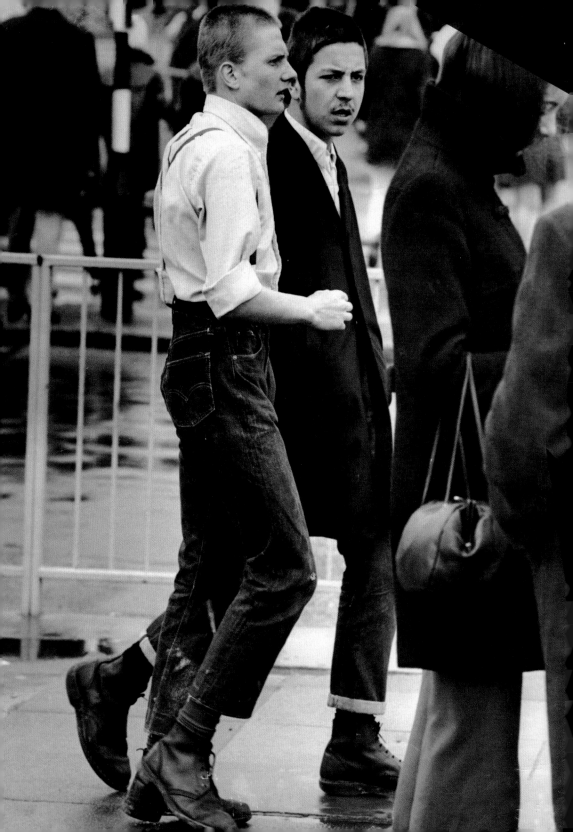

There were a number of fringe benefits for the Suedehead sporting a grown out No. 3, namely that attracting attention from the old bill was a thing of the past. The new 'street smart' look included 2-tone tonics, Pork Pie hats, brogues, button downs, loafers, Sta-Prest, dogtooth, Prince of Wales, Harrington, knitwear, Crombie or Sheepskin. While refinements between Skin and Suede were subtle they were distinctive.

'Smoothes' grew the hair out even longer, up to shoulder length. Of course they got the Richard Allen treatment too with 'Smoothies' published in 1973. They were a short lived sub-sub-sub culture that visually bridged the gap between Suedes and early Slade fans. Check out early images of Slade if you want to see how things looked.

It is also possible that Richard Allen totally made them up. Prove me wrong.

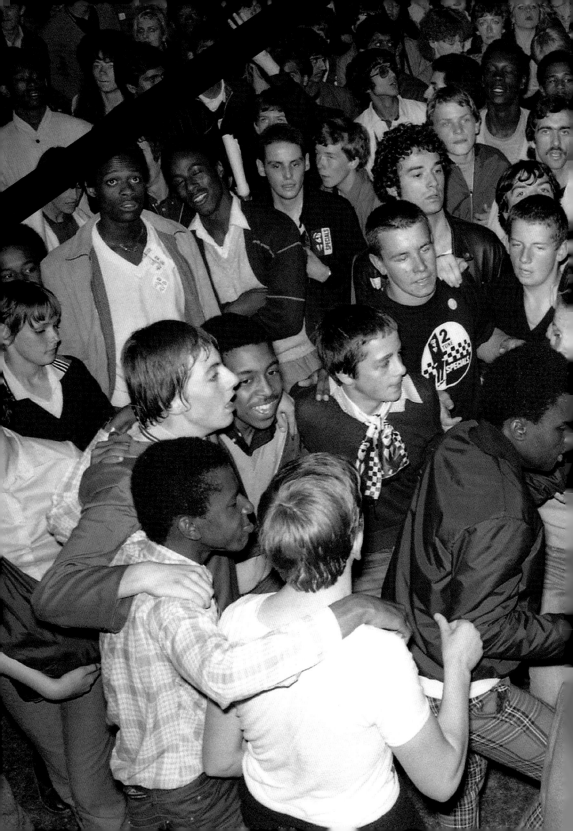

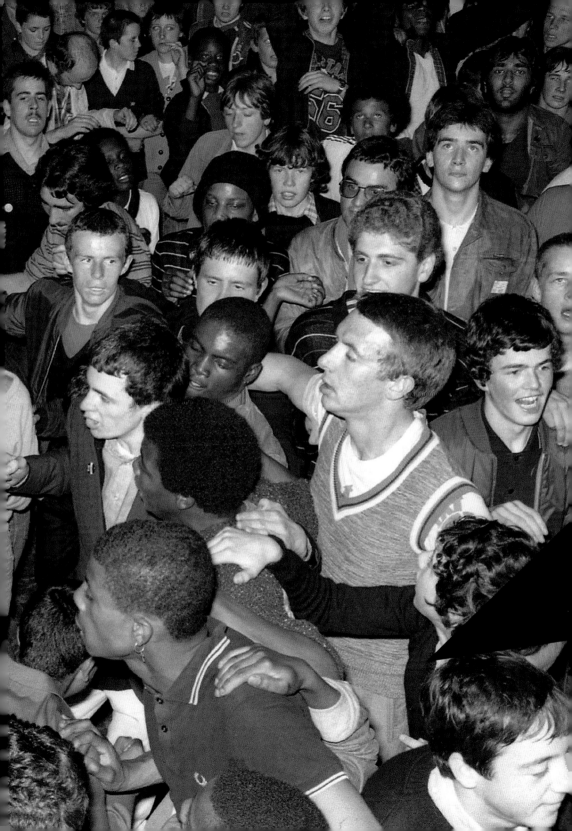

SKA WARS

The return of the Skinhead and the Ska revival went hand-in-hand back in the early days of the 1980's. Punk did more to revive the Skinhead culture than many would admit. In Coventry, black and white musicians came together over a shared love of 1960's reggae and they added punk influences to create the 2-Tone Ska sound.

Jerry Dammers, a former Mod turned Skinhead turned art student, founded the 2-Tone record label in '79 and it soon became synonymous with the new Ska sound. It's aesthetic went right back to the original 1960's Rudeboy image, personified by an early photograph of Peter Tosh when he was in the Wailers - sharp black suit and white socks. This inspired the famous 'Walt Jabsco' logo, by John Sims, which came to symbolise the 2-Tone movement. The Specials released the genre defining album 'The Specials' in 1979.

2-Tone was dance music, and it reflected the real life experiences of working class kids of the new generation who had grown up in multicultural city centres. While the National Front was actively trying to recruit Skinheads, bands like the Specials offered a more hopeful vision.

Nevertheless, even the Specials were dogged by a crowd of confused racist Skinheads who apparently saw no contradiction between loving 2-Tone music and doing the Hitler salute at gigs. They were not the first band to have trouble with racist Skins in their audience. Sham 69 had already thrown in the towel by 1979, after a National Front stage invasion. But that was the pre-cursor to the story of another musical sub-genre - Oi!

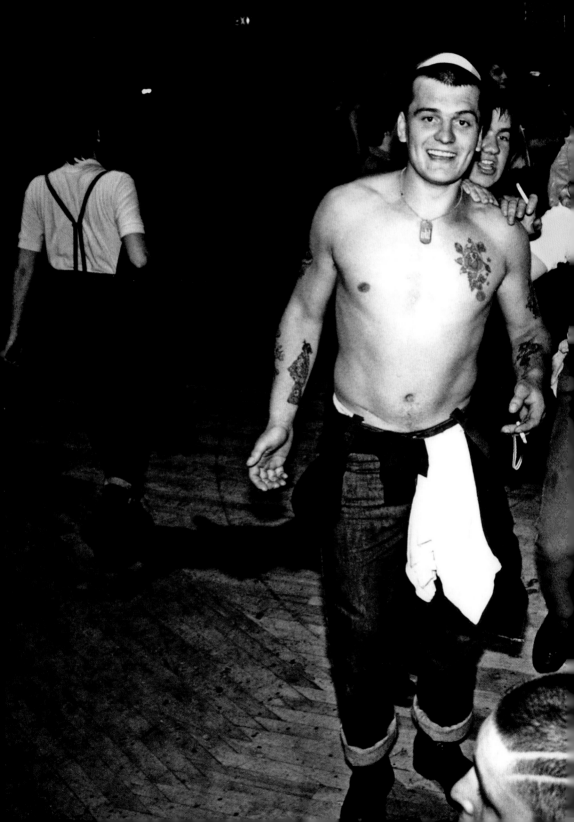

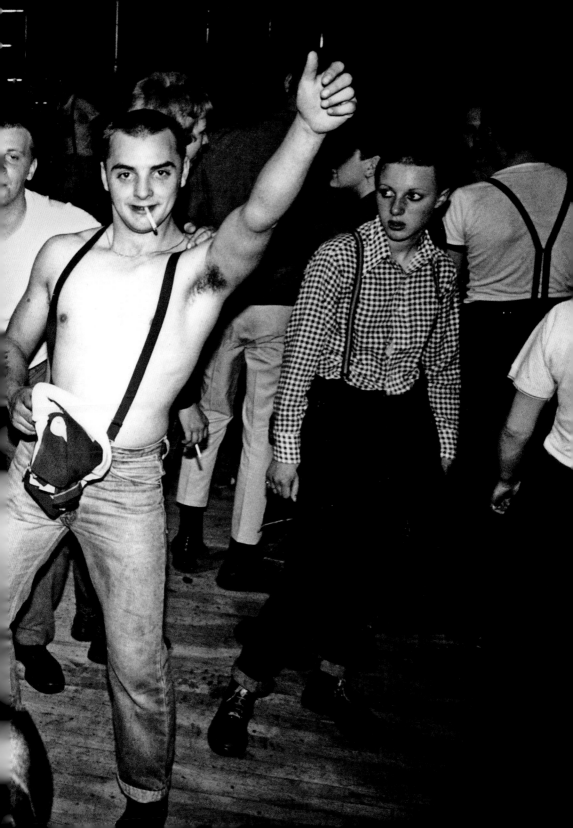

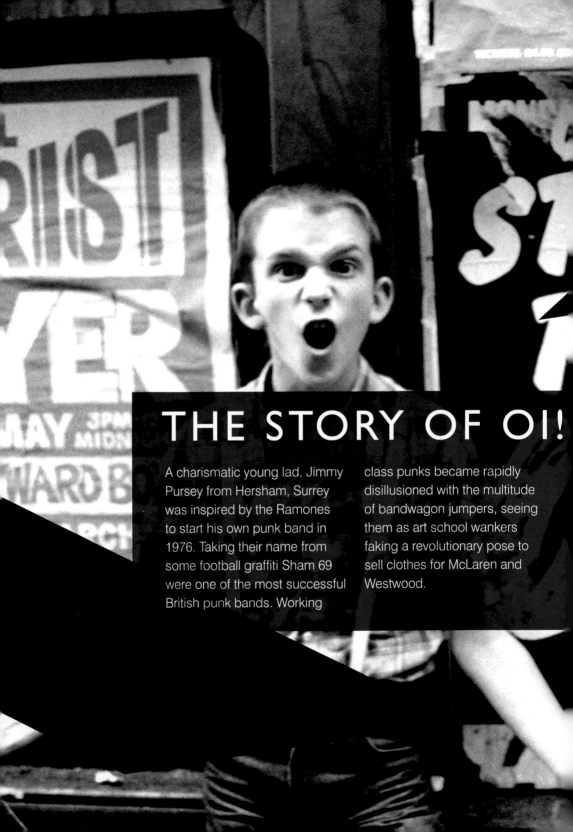

THE STORY OF OI!

A charismatic young lad, Jimmy Pursey from Hersham, Surrey was inspired by the Ramones to start his own punk band in 1976. Taking their name from some football graffiti Sham 69 were one of the most successful British punk bands. Working class punks became rapidly disillusioned with the multitude of bandwagon jumpers, seeing them as art school wankers faking a revolutionary pose to sell clothes for McLaren and Westwood.

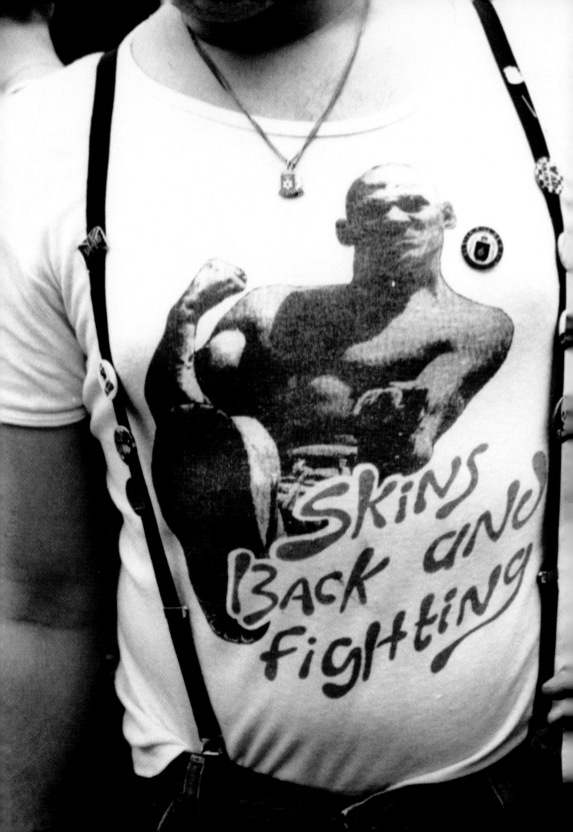

Sham were seen as a more authentic form of Punk, singing about working class realities with clear lyrical messages, taking influences from fans chanting on the football terraces. It was a potent recipe and Pursey pretty much uncousciously invented what was later christencd Oi! AKA Street Punk. Many kids who had come to Skinhead culture through Punk went back to the roots of the style, which was facilitated by the 2-Tone revival and through the work of various Skin zines. Post-Punk Skins were different to the spirit of '69ers in many ways, they were more numerous and diverse and they laid the foundations for the more enduring and international versions of the Skinhead style.

You can't tell the story of Oi! without mentioning politics. Sham were the first casualty of the association between Skins and fascism. Which is doubly poignant because Pursey really wanted working class kids to be united. But Sham 69 began their career at the high water mark of the National Front's popularity in the UK. It was a time when the far-right party polled the fourth most votes, behind the three major parties in the UK system.

Factions within the NF were targeting Skinheads in particular for recruitment, believing that popular resentment towards immigrants could be used to convert young people to fascism. The National Front Youth organisation produced a magazine called Bulldog which it distributed at Punk gigs. Bands like Sham 69, who had a Skinhead following, were prime targets for the NF.

Pursey's band was dogged by political violence and their last gig at the Rainbow Theatre in '79 ended with an NF stage invasion. He gave up on the band, later claiming that Skinhead culture could never be reclaimed from it's association with Nazism. This did not stop him from mentoring two bands that would become key to the next wave of Oi! Punk - The Cockney Rejects and the Angelic Upstarts.

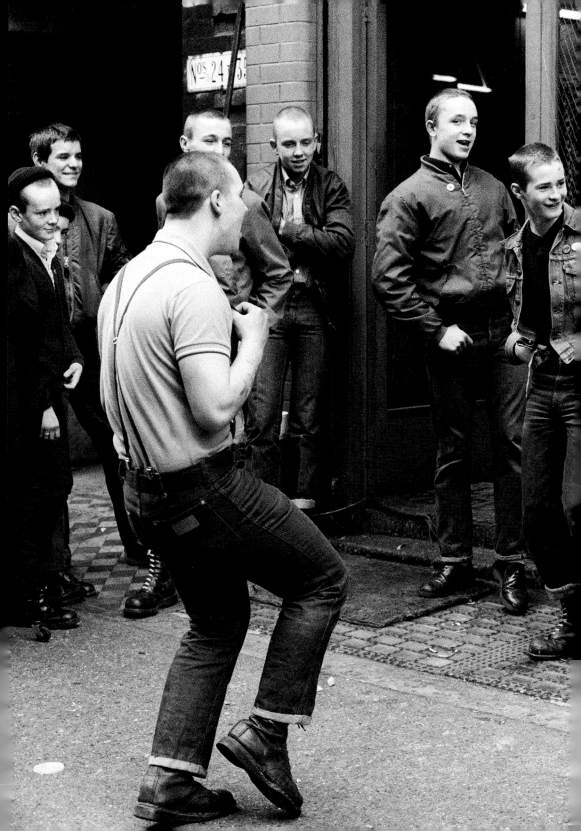

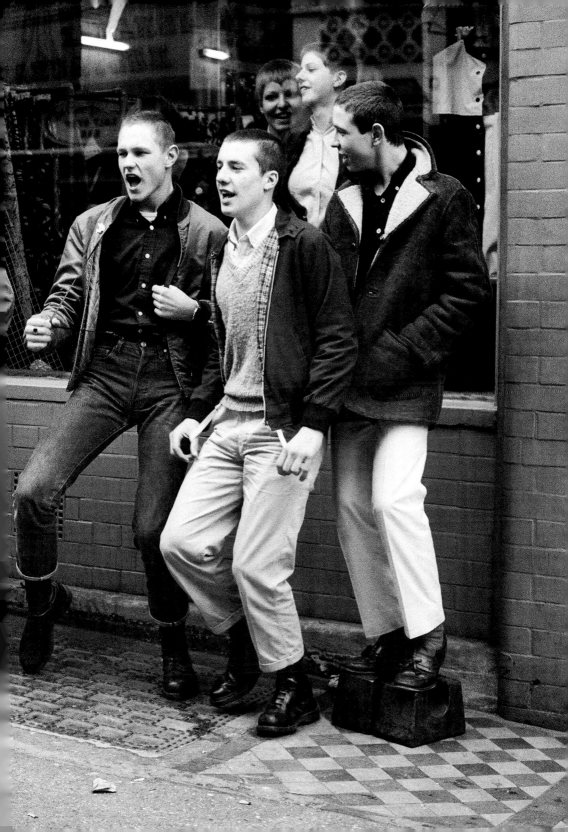

Garry Bushell then took up the baton of championing the scene. He used his position as a journalist at Sounds Magazine, from 1978 - 1985, to foster the development of an Oi! Punk movement. Bushell took the term Oi! (a bit of British slang meaning 'hey you!') from the Rejects use of Oi! Oi! Oi! Oi! instead of 1-2-3-4 to count in a song.

"LET'S hear it for Oi! - the most exciting, despised and misunderstood youth movement of all time." Garry Bushell

Bushell was, and still is, a passionate fan of the bands and he has defended them from the antipathy of the wider musical establishment. Generally derided as 'Punk's idiot brother' and often accused of right wing leanings, Oi! was starved of any mainstream success. This was aggravated by the violence at the gigs, which was at times, though not always, political.

Some of the Oi! bands were left leaning like the Angelic Upstarts, but a few did use their music to promote a right wing

"The Oi poloi didn't need Punk's proletarian wrapping paper – invented backgrounds and adopted attitudes, accents and aggression – because they really were the cul-de-sac, council estate kids the first punk bands had largely only pretended to be."

Garry Bushell, Hoolies, True Stories of Britain's Biggest Street Battles

agenda such as Skrewdriver. This was not a case of Skins creating an extreme political situation, more that an extreme political situation was being played out nationwide as anti-fascist groups clashed with fascist groups in all manner of settings. Oi! was just one of the stages in which this drama played out. Ultimately, Thatcher pulled the rug out from under the National Front by shifting the Tory party to an anti-immigration stance. The far right collapsed as a political force in the 1980's.

The general attitude among Skins today is that politics ruined the first wave of Oi! After the Southall riot - the scene died a temporary death. However, it was soon reborn to a new audience, keen to salvage the best of Street Punk from the wreckage. Oi! continues on today as an international subculture. Many of the original bands have reformed and new bands have popped up all over the place including a thriving Italian scene.

People who are angry, dispossessed, excluded from any chance at success will always be attracted to angry music, outsider music and Oi! represents those people who can say with pride 'nobody likes us and we don't care'. This deliberate attempt to marginalise yourself as much as possible, made extremely visible in the form of facial tattoos and the crucified Skinhead symbol, reflects back the gaze of a society that despises you. It also creates an intense sense of togetherness for you and your tribe of outcasts, outmanned and outgunned, the last resort - this, for many, is the Skinhead mythos. It is the one remaining subculture that the hipsters cannot gentrify. It is the last resort.

SPIRIT OF '69

"The original Skinhead era
represented the cult at its peak,
and everything that has followed
must be judged against it."

Originally published in 1991, Spirit of
'69 was an attempt by a Glaswegian
Skinhead, George Marshall, to preserve
the original spirit of the Skinhead culture.
At the time Marshall, who was in his
twenties, published a Skinhead zine called
Zoot. He hated the way Skinheads were
manipulated by political groups and he
used his influence to attack 'boneheads' -
Skins who did not listen to ska, dressed in
a more militaristic version of the style and
often supported the National Front.

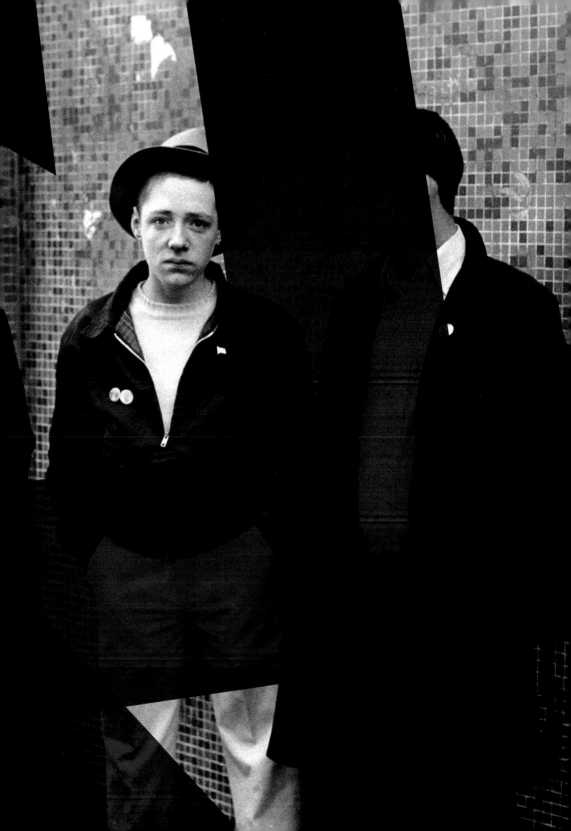

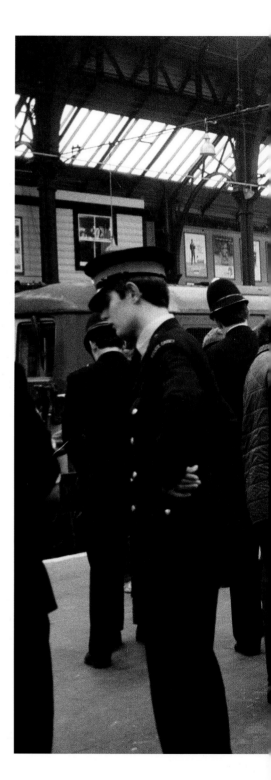

Marshall was one of a few key people to actively try and break the link between Skinhead culture and the far right. Skinheads Against Racial Prejudice or SHARP was an organisation that tried to do the same thing, albeit from a much more left wing perspective. Marshall ultimately wanted to get the 'Politics with a capital P' out of the scene altogether, arguing that you shouldn't have to be far left or far right to be a true Skinhead.

Marshall went on to publish 'Skinhead Times' until 1995, and of course he wrote the book 'Spirit of '69' both publications had a big influence on the survival of a more authentic version of the Skinhead subculture. Copies of his book sell for silly money on the internet - it is the bible for the contemporary Skinhead.

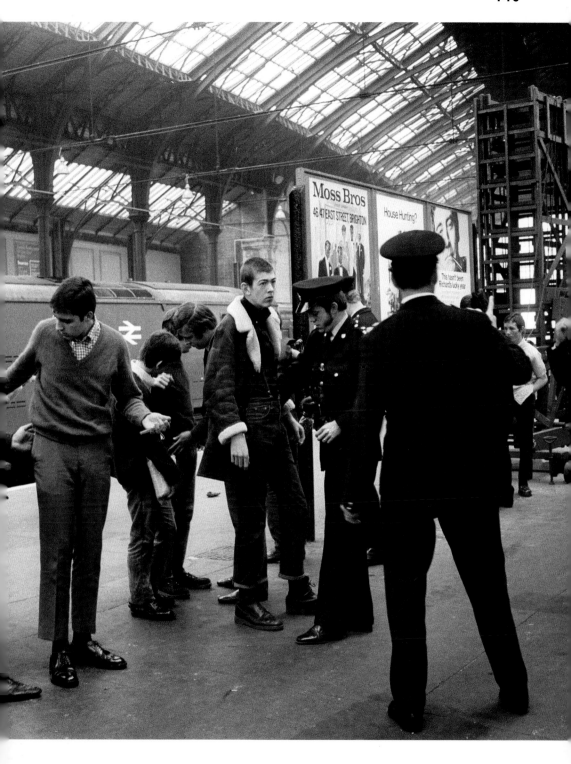

Marshall also shot the documentary 'World of Skinhead' and published various books related to the culture on ST Publishing, including a lesser known sequel to 'Spirit of '69' titled 'Skinhead Nation', among various re-releases of Skinhead pulp fiction. If you feel called to join the Skinhead cult - 'Spirit of '69' is the place to start.

"Pride not Prejudice' means being proud of the cult, the way you look, where you come from, your town, your country. Most Skinheads are working class. You should take pride in that; you're as good as anybody else."

George Marshall,
The Independent (1992)

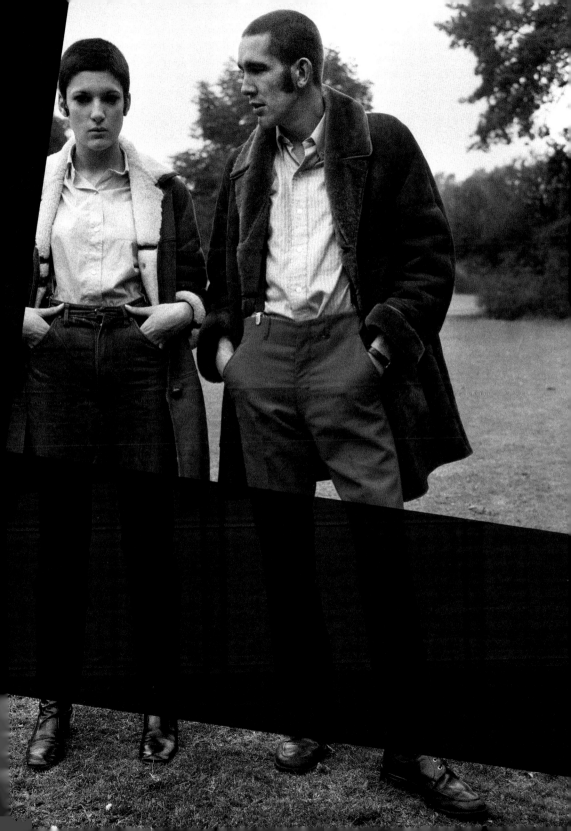

THESE BOOTS WERE MADE FOR WORKING

But they're pretty good for fighting too

Big boots are one the most iconic elements of British and international street style, running from Skinhead to Punk, and into all manner of subcultural flowerings after that. Riot Girls and Grungers, New Age Travellers, Ravers and Hard House Kids, Rockabillies, Goths and Hard Rockers - all have adopted the bovver boot in their day. The story of the safety boot is in many ways the story of the working class in the Twentieth Century.

The early years of the last century of the millennium saw British workers fighting for safer working environments. After World War II, the Labour movement was very strong - the workers felt entitled to a better standard of living, having sacrificed themselves in the war effort. So it was that dockers in London's East End finally saw legislation introduced to protect them from industrial accidents. One measure to achieve this was the adoption of safety boots with reinforced steel toecaps.

The steel toe boot and the donkey jacket became the very image of working class manhood in cockney London. The mental and physical toughness required to do dock work was legendary, dockers were feared and admired for their strength and endurance. Putting on those boots was always a way to get a piece of that respect - to borrow some of aura of those hard-as-nails labouring men. But of course they'd better look like they've been worked in!

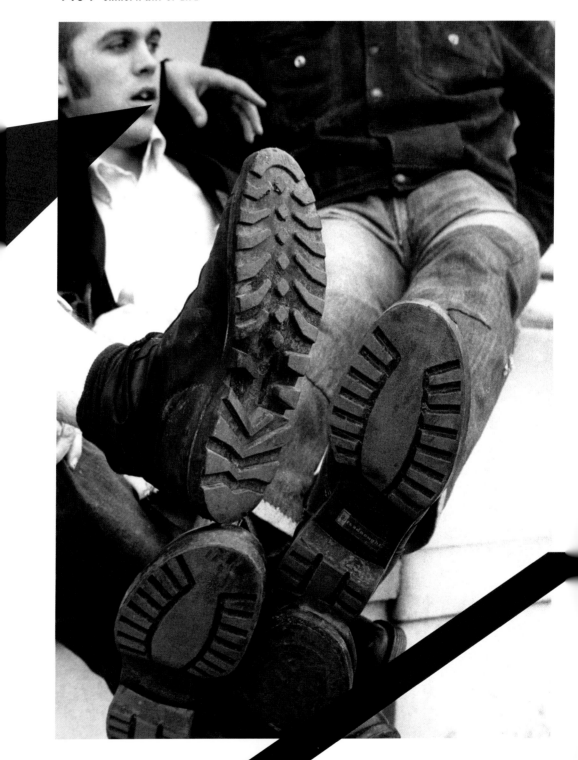

Originally, Skinheads inherited a taste in footwear from their Mod big brothers. If they had the money to show off a pair of brogues at the dancehall, they would. But when Saturday came, you could borrow dad's boots for the football. Steel toe caps were, for a while, a brilliant way to smuggle a weapon into the ground. It didn't take long for the police to catch on - steel toes were banned from the terraces.

In 1971 the film 'A Clockwork Orange' featured boots and ultraviolence, it was banned which helped make it a cult classic and a favourite of Skins and football hooligans alike. Working boots remained a fundamental element of the 1970's football boot-boy Skinhead style. But they were never too precious about particular brands. Boots were for fighting - shiny shoes were for dancing.

In 1966 Pete Townshend was the first pop-star to wear Doc Martens, which would have been the right moment to capture the attention of the younger, scruffier element of the Mod cult. Doc Martens were designed in Munich in 1945 by Dr. Klaus Maertens as a therapeutic shoe for people with injured feet, hence their legendary comfiness. They began exporting in 1958, The British Boot Company (then Holts) in Camden being one of the first British stockists, and the boot secured its place in pop culture in the late 1960's.

"

"I had all the good shit. A lot of Skinheads didn't have a fucking clue; they'd wear some horrible old tat. I was a snob when it came to clothes. If you didn't have the right stuff, I didn't want nothing to do with you."

Steve Jones, The Sex Pistols in his autobiography 'Lonely Boy'

Once you break a pair of DM's in, you can live in them – they're that comfy. If you've never woken up on the kitchen floor at a house party, face in an ashtray, with your Doc Martens still on - you haven't lived.

It was during the late 1970's as Punk and 2-Tone sparked the Skinhead revival that brands like Doc Martens took on their legendary status as Skinhead boots. It was then that the trend towards higher and higher boots came about, and Skins turned up their bleach splattered Levis 501's to show off the number of eyelets they had.

The Punks went for a wider range of boot colours - notably cherry red, which had an impact on the Post Punk Skins.

The DM is never quite as scary as army surplus combat boots paired with an MA-1 flight jacket, braces worn hanging down, completely bald head, and facial tattoos - a look that says 'You may as well arrest me now officer'. Doc Martens, whether oxblood or straight up black, imply a knowing engagement with Skinhead traditions, a reference that you know where you come from, you're not just some bonehead kid who wants to look like a psychopath.

One of the the police's favourite pastimes was to remove Skins' laces whenever there was the slightest hint of trouble, be that at a football ground, gig or even on the street.

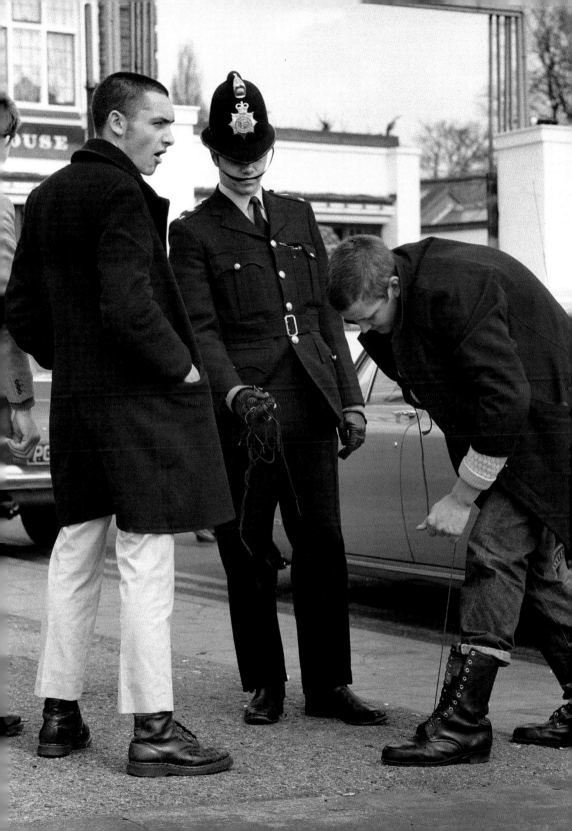

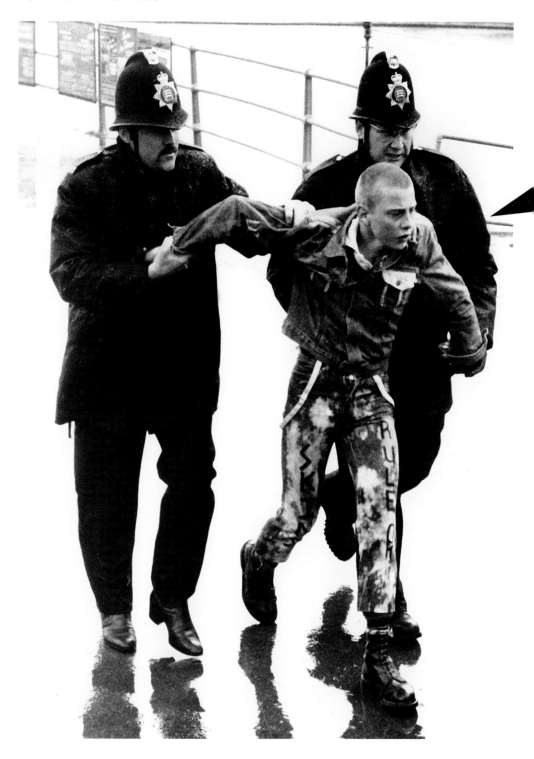

The Skins must have been horrified as the 80s progressed when overnight, every man and his dog started wearing trainers. The final and total victory of casual sportswear in British street style would have had the old Mods spinning in their graves. As individuals made the transition from Skin to Casual, Pringle and Kappa replaced Lonsdale and Ben Sherman, Levis became Farahs with Samba's taking the place of Docs. Last but not least in a final twist of ignominy, the No 2. crops morphed into wedges, curly perms and curtains.

It was Run DMC that held the smoking gun. It's likely that hip-hop contributed to the death of the bovver boot. (Ironically, late 1990's gangster rappers idolised the Timberland boot for much the same reason that Skins loved their DM's.)

One of these days these boots are gonna work all over you...

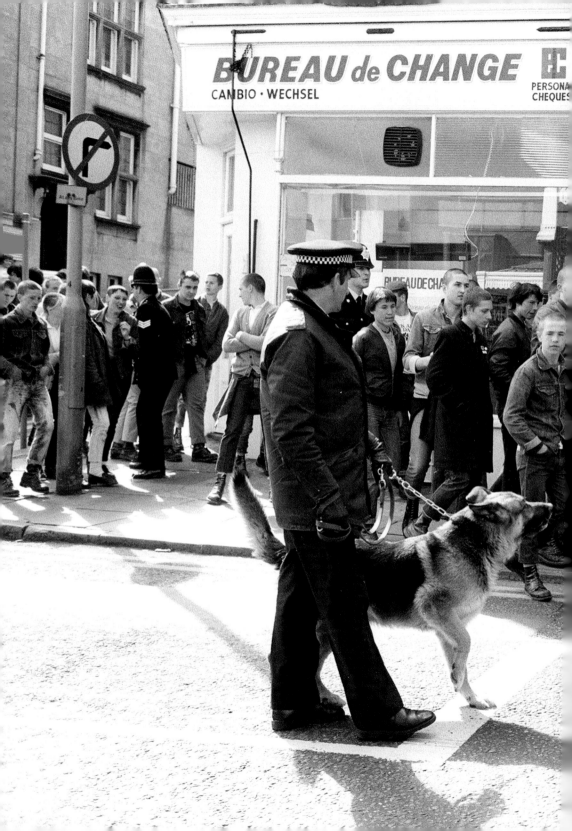

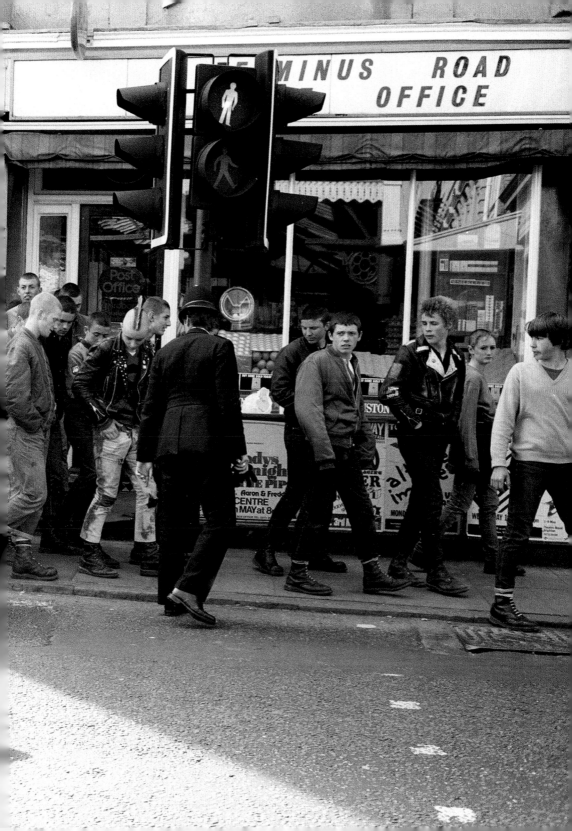

THE LIQUIDATOR

Bearded sociologists have their uses. In 1964 the Birmingham Centre for Cultural Studies opened its doors for business and lasted until 2002. The Birmingham school were among the first academics to take youth subcultures seriously and produced many of the most influential works on the subject. At a time when most academics ignored contemporary working class culture - the Birmingham Centre was at least paying attention.

This is how John Clarke came to write about Skinheads and Football Hooliganism in 1973. One of the 1968 influenced radical student lefties that Joe Hawkins would have loved to kick repeatedly in the bollocks, Clarke wrote a paper "Football Hooliganism and the Skinheads" (1973) which gives us a window on to the links between the Skinhead cult and terrace culture.

Clarke claimed that football was integral to working class culture because it matched core working class values. These were "Excitement, physical prowess, local identity and victory." As a quick thought experiment, if we invert these values do we get something that looks like middle class culture? "Mindfulness, intellectual prowess, international identity, avoidance of conflict." It kind of works doesn't? Looks like Brexit vs. Remain.

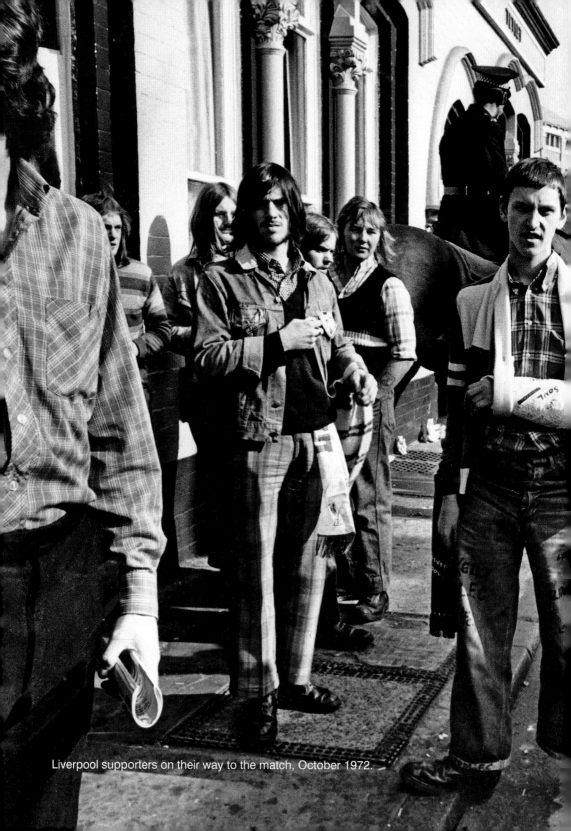

Liverpool supporters on their way to the match, October 1972.

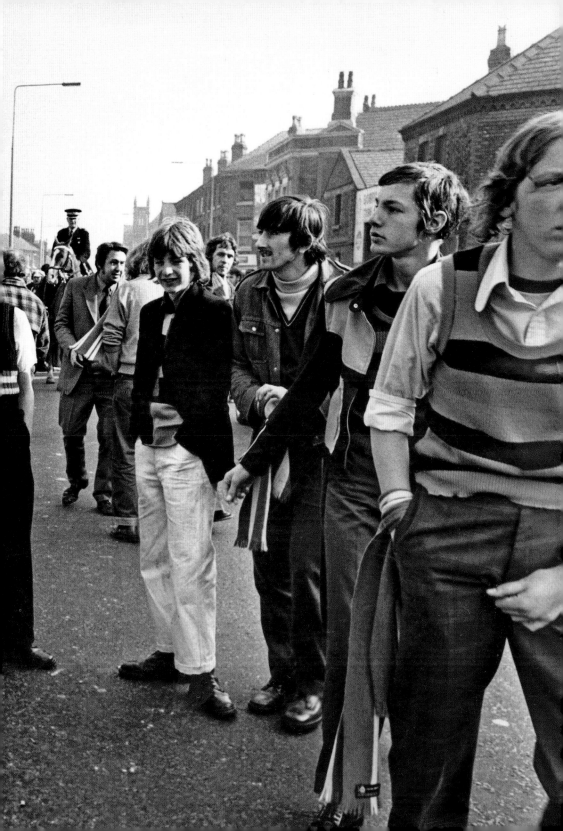

These are old ideas about the labouring class - and they come from the idea that hard physical work creates the need for physical prowess. Boring repetitive labour creates the need for excitement and 'letting off steam'. Local networks of support, extended families and the lack of freedom of movement create strong territoriality. And victory in sport, or in violence, is supposedly the only way for working class men to experience a fleeting moment of high status. So football then, offers a potent package. You can satisfy all these needs in one day at the local football ground and, even if you do get arrested, you can still be back at work on time come Monday.

The excitement, the passion and pride and the 'psychological sense of being at one with the crowd' were most intoxicating from the stands. Football was essentially a game of physical combat - in 1973 you could say this with a straight face, images of Neymar rolling around like a big girl's blouse were yet to be witnessed. Footballers were as hard as their fans.

The point that Clarke makes is that casual violence was so embedded in the culture of labouring men that it hardly merited talking about. They didn't see it as a problem. And they always claimed that involvement was more or less optional.

There was always a lot more smoke than fire. And although violence was temporarily legit, it was limited - it wasn't supposed to get out of hand.

Much later on, organised hooliganism would lead to some pretty extreme violence and even deaths. But this is football as described in 1973. Most of the players were working class and many of them were local to the area which the teams represented. And this leads us to one of football's enduring myths - it is a route to success that does not depend on being born into the right social class. The working class football superstar, like Harry Kane of Walthamstow, is still a powerful influence on young men growing up in Austerity Britain.

Already in 1973 the game was in the early stages of gentrification. And a key part of that process was redefining the 'true supporter'. Increasingly the rough and ready chaps who occasionally fought at the matches were rebranded as 'not real football fans' who were only there for the violence. They became 'hooligans'. The true fan was then the new middle class audience who appreciated the technicity of the play and sat in a seat while he watched. The increase of 'hooliganism' could then be seen as a response by desperate kids to hold onto the elements of the game that were in the process of being purged.

Art imitates life and life imitates art. As the media blew up the folk devil version of the hooligan, the hooligans played their part and set about fulfilling the myth. They fed each other in an explosive cycle throughout the 1970's and 1980's leading up to the slick organised and weaponised violence of the Casual firms.

But the Skinheads were there first. Clarke places their arrival on the terraces at the end of 1968. All the elements of their style were there from the steel capped boots to the Crombies in cold weather. And it was a uniform, which was precisely why it had such a visceral impact at the football. They looked like an army. An army of working class boys who were no longer supposed to exist.

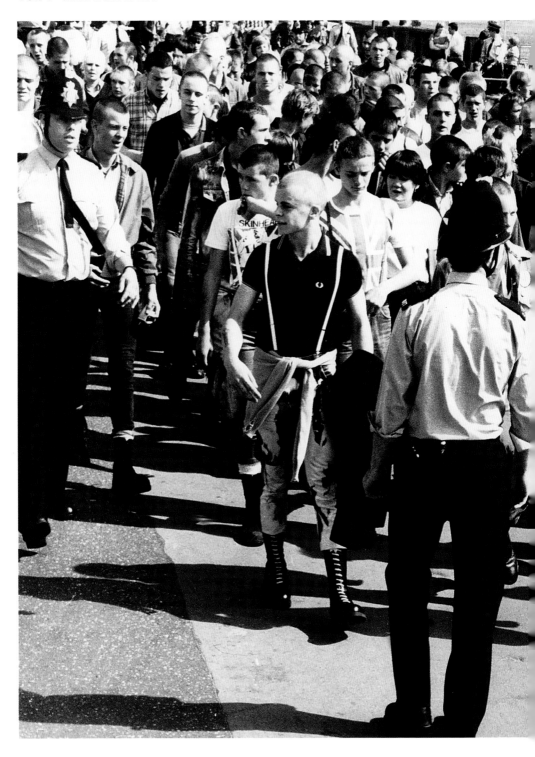

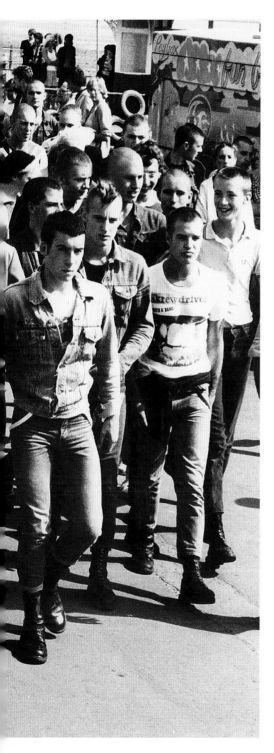

Skins were targeted by the police and the football clubs. But they were idolised by working class men in the town's and cities that they visited to support their teams at away games. From West Ham to Rangers, Sheff Utd to Man City they spread the style around the country, growing more aggressive. Attacking the home team's end, trying for pitch invasions and rampaging through the home team's town centre.

The police responded by stopping buses and sending them back, escorting away fans to the ground, corralling away fans after the games and making them remove their boots or even confiscating their bootlaces and belts. Steel toe caps were banned from stadiums and Skins were searched for weapons on the way into grounds. Often, Skin girls were used to smuggle weapons in. Skins invented the 'Millwall Brick" a makeshift newspaper cosh.

By 1969 the Skinhead football hooligan was hitting the national newspapers and well on the way to folk devil status. So it really was football, not music, that launched the Skinhead cult on the national stage. The regional football Skinhead may have known nothing about Desmond Dekker, but he wore the right gear if he could find it and afford it.

THE LAST RESORT

Last resort *(noun)*
A final course of action used when all else has failed.

Micky and Margaret French owned a punk fashion boutique in Goulston Street near Petticoat Lane. They had been in business since 1971, serving various youth trends and in 1978 they committed to being the only Skinhead clothes shop in the country. While they still offered Psychobilly and Punk styles, the shop became the focus of the Skinhead revival for many young people - not just in London but around the country.

While Punks had been catered for in the West of London, The Last Resort found iteslf amongst the market traders of Petticoat Lane and the mythical East End. The shop was a magnet for the disenfranchised London Skins and a pilgrimage for the rest of the UK.

The location was perfect - it was so deep in the heart of the East End you could feel the ghosts of Jack the Ripper's victims eyeballing your eel pie. If the Cockney urchin was the grandfather of the 1980's Skinhead then this was Skinhead mecca. Micky and Margaret encouraged Skins to hang out at the shop, and when they were banned from pretty much every pub in London - hanging around outside the Last Resort really was the Last Resort.

The shop had it's critics. Rumour has it that the mail order service was notoriously unreliable, and some of the East End London Skins who fancied themselves the elite at times looked down on the busloads of provincial Skins who came down to visit the shop.

But you have to remember it was almost impossible to find the right gear. The glory you would find if you were the only Skin at home who had genuine Levi 501's, flight jacket, Ben Sherman shirt or Harrington jacket. The shop also did a sideline in Punk attire including brothel creepers, mohair jumpers, tartan heavy duty bondage trousers and the usual assortment of Punk T-shirts including The Clash, Crass and Siouxisie. Even the shop's advertising was a point of access to Skinhead culture, with it's sarcastic and menacing slogans and it's brutalist Crucified Skin artwork.

Whether or not their 'Notice to Skinheads' – a request for customers to 'Patronize the shop that patronizes you!!' was a sarcastic piss-take or not is still debatable.

When you, the provincial bootboy from some random small town, like maybe Darlington or Carlisle, got off a six hour trip on the National Express and made your way from Victoria to Aldgate East, wandering around asking people the way to Goulston Street (no Google maps) in your marked foreign accent (northern) you were naturally more than a little bit on edge. East London in the 1980's was not a collection of gourmet coffee shops and hipster beards. It was still rough as arses. But it was a true pilgrimage to the roots of the Skinhead cult, right there in the mean streets of cockney London, where you really can hear the Bow bells ringing. And contrary to any expectations that you may have had - the welcome was typically a warm one.

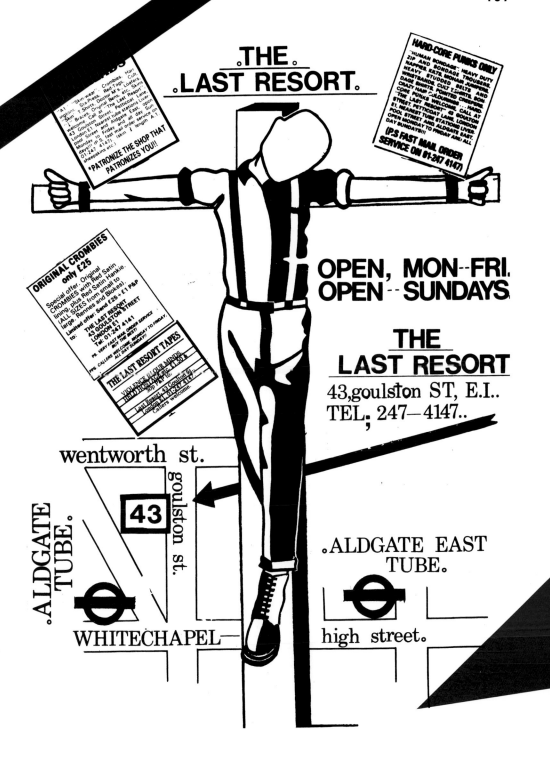

CULT—T—SHIRTS
'a way of life'

1 sons of Oi! Oi!

the sound of one boot kicking

2

3 no fuss, no mess, just pure impact!

last resort 4

5 crucified skin

6

7 no's 5&6 available with jack.

8 plain jack

skinhead 'PAIN OF LIVING'

british made s,m,L, £2·99 - 50p,p·p·

Prominent tattoos had been part of the original 1960's cult but they became a integral to the 1980's Skinhead look. They were raw, basic and often in painful places like the inside of the bottom lip. They demonstrated, as tattoos always have, a certain level of disregard for pain and a refusal to think about the future. Nothing could be more committed than displaying your Skinhead status with a permanent facial tattoo.

The iconography of the 1980's Skin was defined by an artist called Mick Furbank from Leeds. Furbank designed the crucified Skinhead image for The Last Resort shop, inspired by the crude style of traditional working class tattoos. It fit the 1980's scene perfectly, the sense of being martyred for the sins of others, the sense of being crucified by the media and the establishment - the noble victimhood that Skins felt at that time. It became a popular tattoo, alongside established Skin favourites like the British Bulldog, the Union Jack, football club crests, swallows, spider webs, weapons, slogans, the odd right wing icon and imagery from a Clockwork Orange.

No Mess, No Fuss – Just Pure Impact. The Last Resort.

Illustrations on pages 167/168: Last Resort mail order catalogue pages from early 80s. Artwork by Mick Furbank

RUNNING RIOT: VIOLENT DELIGHTS AND EXTREME EXPERIENCES

As Steven Pinker pointed out back in 2011, the world is less violent today than at any point in history. It might not seem like it, but Britain is far less violent now than it was in the 1970's and 80's. Where once your teacher, your dad, the local bobby or even a shopkeeper could have gotten away with boxing your ears, today violence has become a strict taboo. It is hard to imagine now, a time when adolescent street fighting was considered a normal part of growing up - barely registered by adult society.

The unspoken secret, the elephant in the room - the bleeding obvious hidden in plain sight when you look back on Skinhead culture is this - violence is really exciting. Ex-Skins might be tight lipped on this aspect of the culture - but it was real. Skins didn't just look hard. Skins were hard. Just because the tabloids exaggerated the smoke doesn't mean there was no fire.

Getting a crew of nutters together, hiring a bus, descending on some unsuspecting seaside town like a horde of barbarians - what fun! For those who have nothing - you can feel like a champion on the field of some glorious battle for a day, you can live on those stories through the grinding boredom of the weeks to come, standing on street corners in some schmucky small town where you've been barred from all

the pubs and you've spent all your wages anyway. In fact, its these very stories that provide the basis for discussion at various Christmas get-togethers and piss ups and are the glue that bind together those that were there in for decades to come.

These kids were making memories. While the sociologists tried to intellectualise their deviant behaviour - the kids were just happy causing aggro. In Alan Clarke's 1989 TV Film 'The Firm' the character Nunk spells it out "We just like hitting people."

Violence is a form of communication. And it is generally used to 'discuss' status. When the Skins turn up in your parish to cause bovver they are like the uninvited witch from the fairy tale.

Here we are! Come and have a go if you think you're hard enough. We're the uninvited and now we've just crashed your little party and we're going to fuck it up! That's a kind of freedom too - embracing having no status at all gives you permission to ignore the rules of the status game. The battle of who could care less. An inverted kind of status. The Skinhead who loses the worst - gets glassed and then arrested and fined, he's the guy who will be the hero when he eventually gets back home.

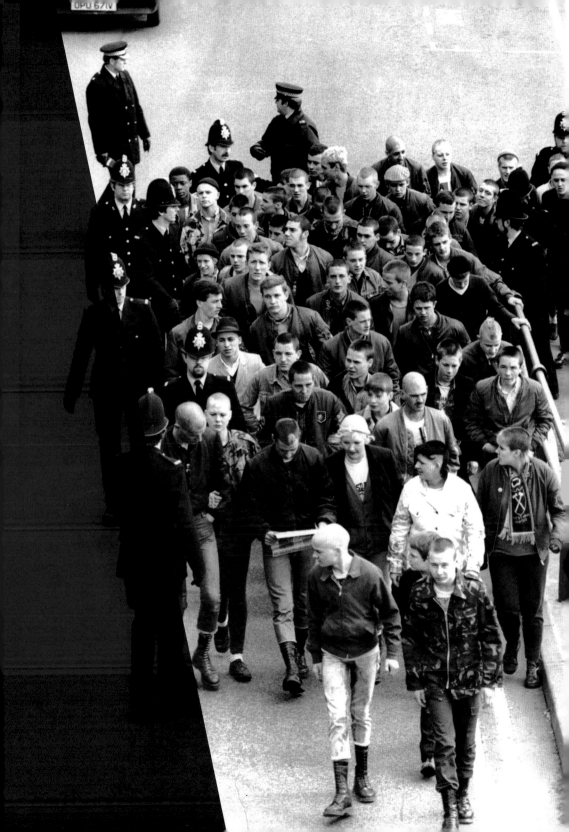

They wanted extreme experiences. To chase extreme feelings. But then they wanted to go back home again to live their traditional working class life, finding that weird balance between conservative values and explosions of carnivalesque violence that constituted their response to the world.

Brighton, Southend, Blackpool, Scarborough. Skins flocked to the coastal honeypots like flies round shit. Transit vans full of boneheads were followed by a squadron of Lambretta and Vespa riding Scooterboy outriders, Bank Holidays were literally carnage. Like sparks thrown in a tinderbox things could kick off at the slightest provocation. The mixture of sea air, beer and sun proved to an irristably potent mix to the visiting hordes that had been let off the leash for the weekend.

In a Britain where casual violence was much more common, the Skinhead culture cannot really be solely blamed for fetishing violence. They only took what was already there and pushed it a little further. Doubtless some of these kids in the 1980's who were so feared as Skinheads - were among the first who got into Acid House and Ecstasy towards the end of the decade - when legend has it - the love drug converted a nation of macho football thugs into metrosexual ravers.

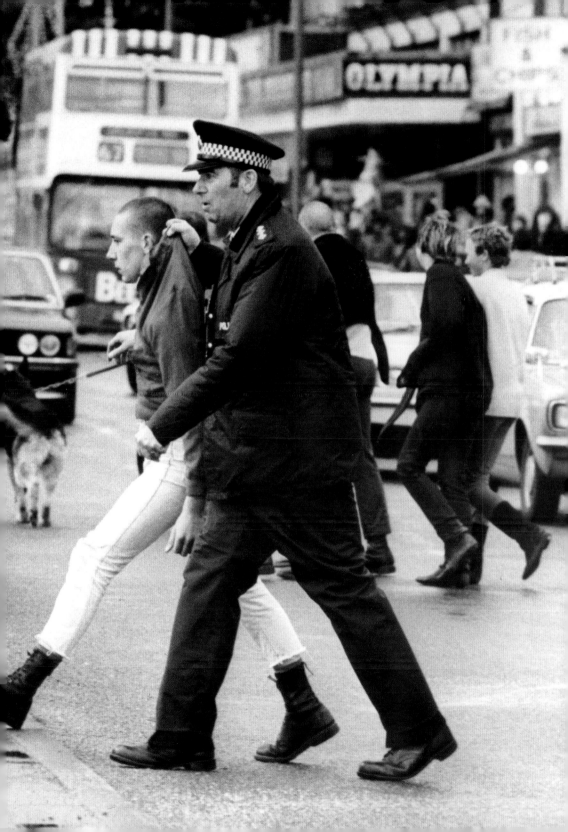

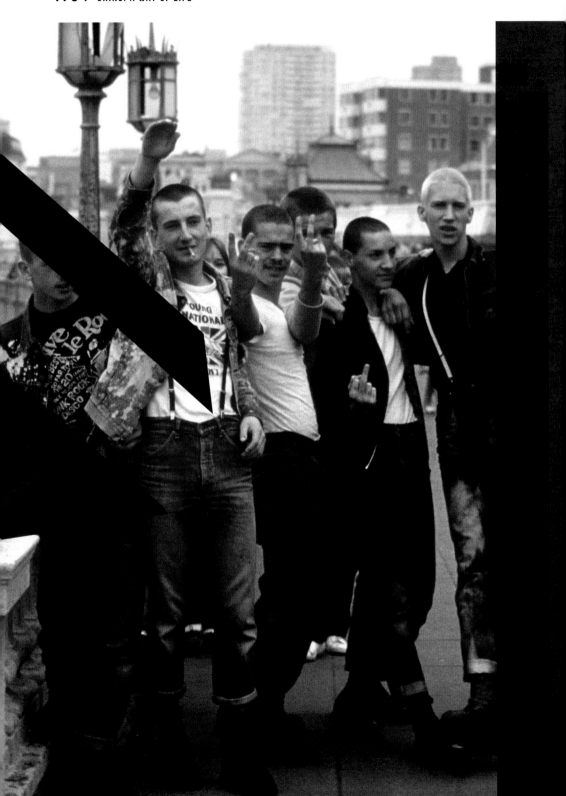

SKINHEADS AGAINST RACIAL PREJUDICE

From the beginning of the second wave of Skinhead culture, there have been attempts to break the link between Skinheads and right wing politics. Rock Against Racism was formed in 1976 in London partly in response to a drunken rant by Eric Clapton in favour of the National Front. The right responded by forming Rock Against Communism.

In 1987 the same pattern appeared when white nationalists formed 'Blood & Honour' as a network to promote neo-nazi Skinhead music. The same year in New York Skinheads Against Racial Prejudice (SHARP) formed to combat racist skins and promote the traditional Skinhead values. Oi! was in its third wave, and the Oi! Influenced hardcore scene had a lot of Punk Skin followers. Bands like The Press, Life's Blood and the Oppressed supported SHARP. And it was Roddy Moreno of the Oppressed who designed the Trojan Records based SHARP logo, bringing the idea of SHARP Skins to the UK.

"If you do racist, you can't be a Skinhead, because Skinhead wouldn't exist without Jamaica".

Roddy Moreno,
The Oppressed

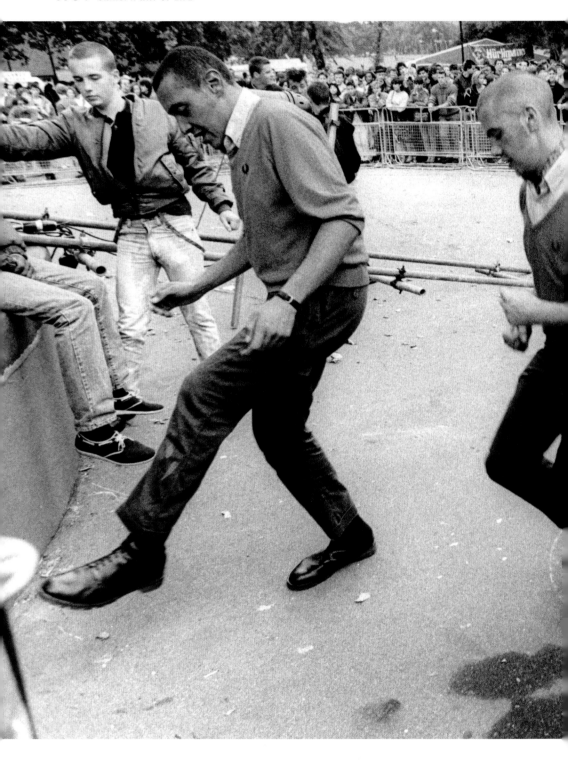

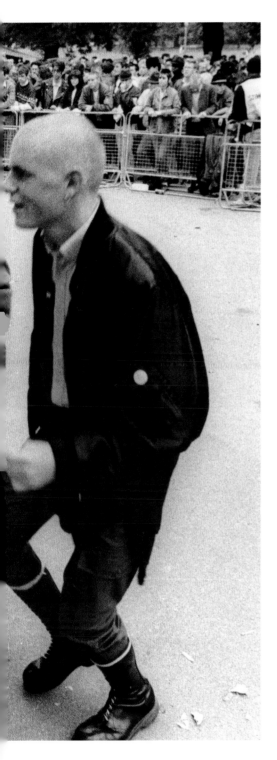

SHARP was more a personal affiliation than an organisation and it was promoted through various zines like 'Hard as Nails'. SHARP spread to Skinheads around the world and was successful in providing an alternative to 'bonehead' culture that was not affiliated to a hard-left political agenda.

Left: Skinheads dancing at a music festival on Clapham Common, London, Britain 1985.

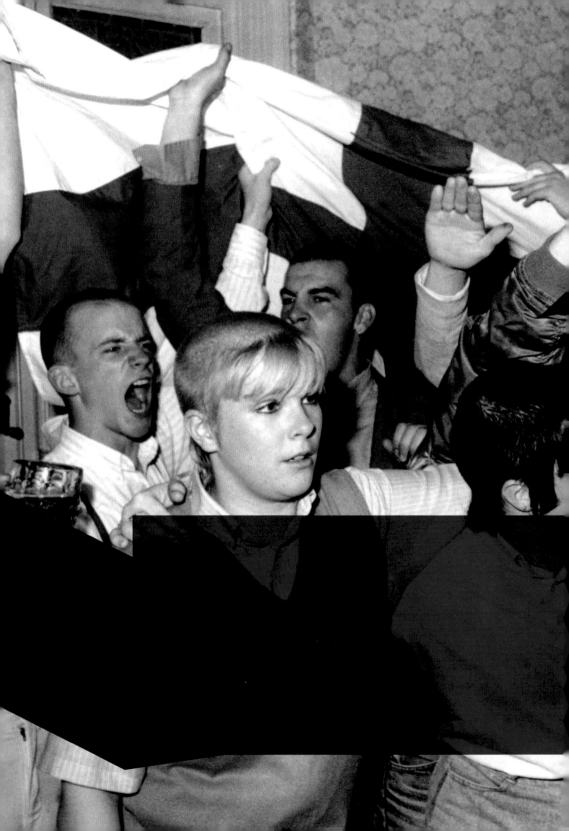

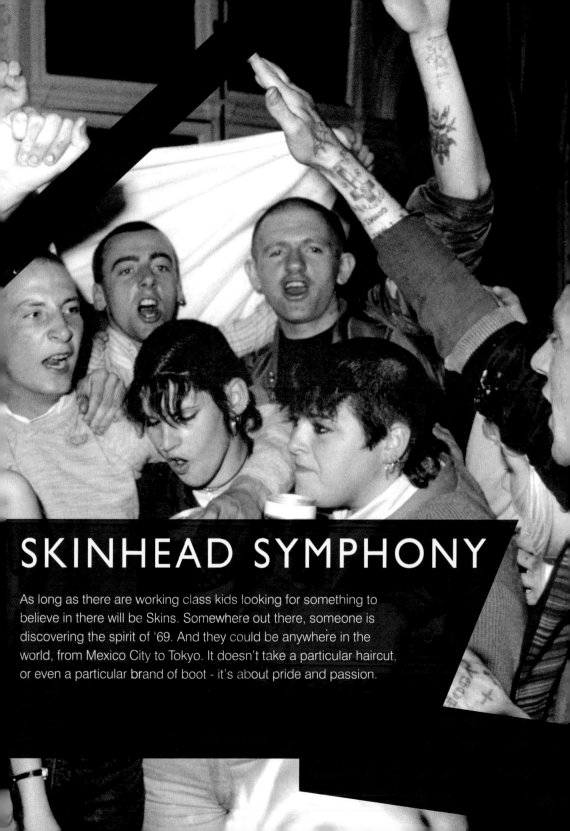

SKINHEAD SYMPHONY

As long as there are working class kids looking for something to believe in there will be Skins. Somewhere out there, someone is discovering the spirit of '69. And they could be anywhere in the world, from Mexico City to Tokyo. It doesn't take a particular haircut, or even a particular brand of boot - it's about pride and passion.

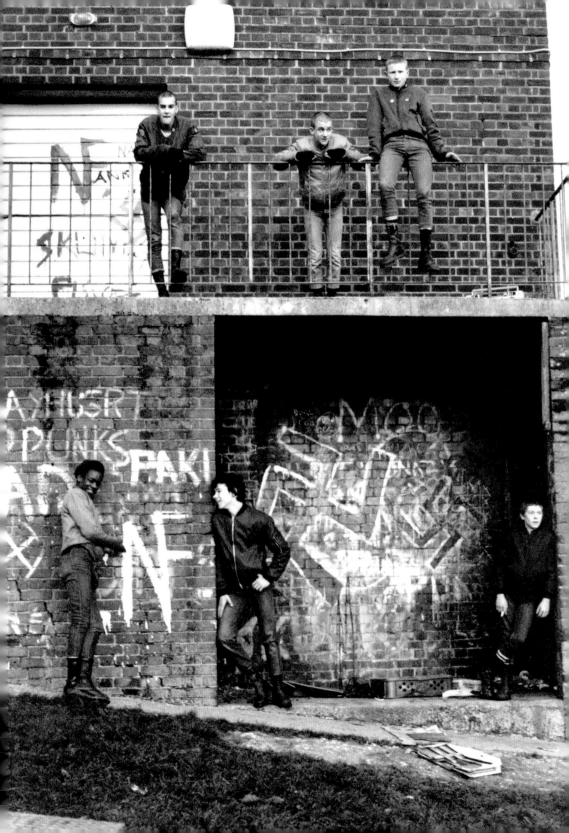

Even though you know you are potentially misconstrued as a reject, society's underclass, undereducated and underpaid, it could'nt be further from the truth - you take pride in yourself, your neighbourhood, your family and your mates. This isn't about intellect or the perception of the lack of it. You're switched on and streetwise. You know you always look proper even if the whole world THINKS you're scum. You polish your boots till they gleam, bootboy. Just like your cockney grandma, who scrubbed her front step till her fingers bled pride and passion, whatever your situation.

You know the system is stacked against you, but you are proud of your country, even if you are cynical about the politicians who run it. You don't need to read the Socialist Worker or the National Front's Bulldog to know what you think. You don't judge people by the colour of their skin, because you know what it feels like to be judged, to be discriminated against, crucified.

But so fucking what. Life is for the living. There are laughs to be had, styles to look sharp in, scooter runs to go on, football to follow, tall tales to share and pubs to haunt. And then there is the music, whatever flavour gets you stomping. Ska, Punk, Oi!, Trojan, 2-Tone, Reggae or Dub. The Upstarts, Sham, Cockney Rejects, Specials, 4-Skins, Blitz, Last Resort, The Business, Toots and the Maytals, Desmond Dekker, The Upsetters, The Pioneeers, or Symarip.

And no you won't take any shit. And you might fight your corner, stand your ground - because you don't live in some gated community with armed security guards and sometimes you have to defend yourself and the people you love. An honest fight, not a faceful of acid.

Skinhead heaven will be right next door to Valhalla. They'll call the Vikings hippies and all hell will break loose. The tabloids will have a field day. Desmond Dekker will provide the soundtrack.

And if you're not working class, you'll get a kick in the bollocks.

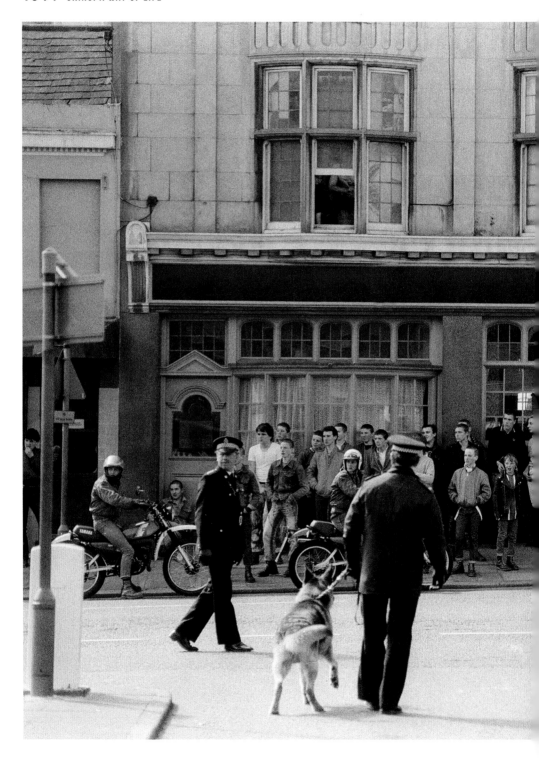

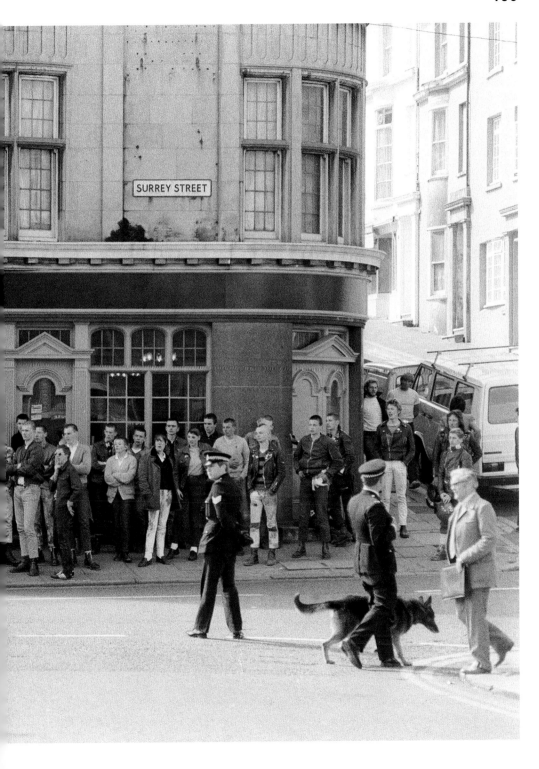

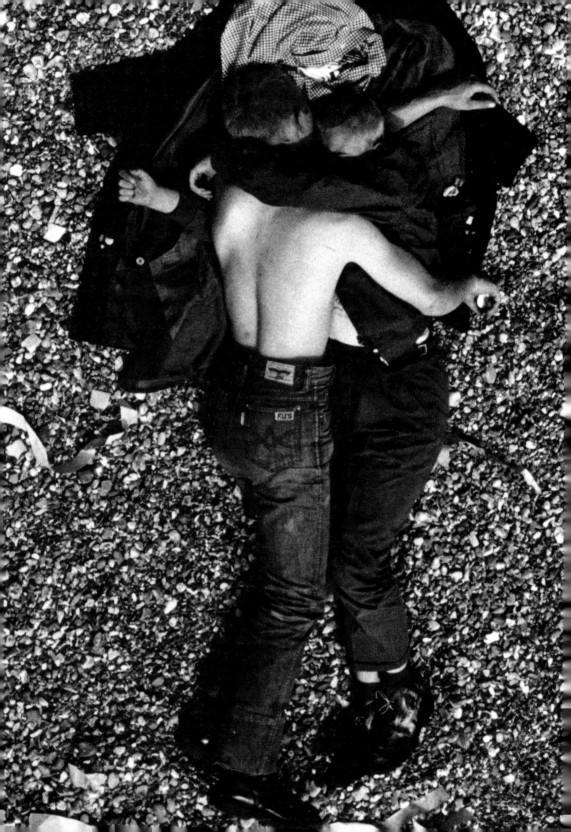

WHO MAKES HISTORY?

You do. Not by simply living your life. You make history when you try to tell people about something in the past. The facts you choose, the words, the way you highlight an element of the event, the way you spin it - history is this highly dubious process of making a story out of the raw and infinitely overlapping phenomena of reality. We always use the substance of our memory to serve our interests in the present.

And then you get something even more abstract - stories woven out of other stories. When we set out to collect first hand recollections and use them to generalise a new story, like the one in this book. We're trying to find the essential elements, the universals, that made the subculture what it was - as if culture was a thing you could map out and define. You can't. The whole enterprise is doomed before it starts.

However, there is no single truth. The only reality for you is the way you see it in your own mind. Ultimately we set out with the task to chime with your internal sense of what is authentic. But if it doesn't always hit the right note - remember, it's just one version of a story that was first written by hundreds of thousands of participants. We would never assert that our story is **the** story. You might see it differently.

The truth is, subcultures are like rivers: you can never step in the same one twice.

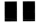

"History is written by the victors".

Winston Churchill

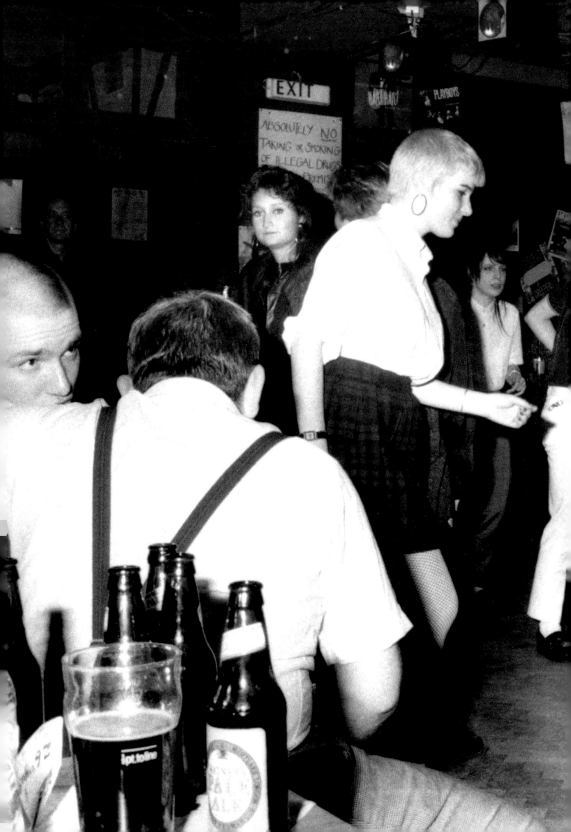

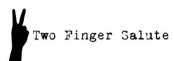 Two Finger Salute

Youth cultures never die. Every time someone falls in love with a style, an attitude, a posture, a way of seeing the world; that subculture is reborn, just as imminent and vital as it was the moment that it first appeared.

The Two Finger Salute series explores the enduring power of British Youth Rebel cultures from 1950 to the present day.

Celebrate the DIY attitude of the kids who made something out of nothing.

And if you are feeling a little insolent, and a little iconic, try flicking the V's.

Part of the Two Finger Salute series:

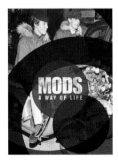

MODS: A Way Of Life
Patrick Potter
£16.95
ISBN: 978-1-908211-59-0

SCOOTERBOYS: The Lost Tribe
Martin 'Sticky' Round
£16.95
ISBN: 978-1-908211-75-0

Tradition

Respect

Loyalty

Pride

Honour